Before I Forget

This is a chronicle of the life and times of Robert Dumont Smith, a talented artist, horologist, pianist and amateur thespian who also painted the scenery for many amateur productions. he had exhibitions of his work at Foyles Art Gallery, Liberty's and other galleries, and also exhibited at the Royal Academy and the Paris Salon but, even so, his work was not as well known as it warranted, and the examples reproduced here underline this fact.

Robert possessed a wide and deep knowledge of art, and his comments are incisive, intelligent and often thought provoking. He was a sought after lecturer and, although much of 'Before I Forget' revolves around art and the artistic circle he moved in, this is not just a book about art.

The episodes in his life in South London are conveyed with humour and warmth, just like the man himself. In late life he had a severe illness, and was the victim of some appalling burglaries, but his nature was to rise above all that confronted him, and this comes through so clearly in his thoughts and observations.

Full of real characters and incidents, here is an autobiography that will capture the reader's attention and admiration for someone who deserved to have been better known during his lifetime.

His long time associate Joan Crole has edited and introduced Robert Dumont Smith's story.

Before I Forget

Autobiography of Robert Dumont Smith

Edited and Introduced by
P. Joan Crole

Cherry Books

Date of Publication: January 2000

Published by Cherry Books
Garrick, Pollard's Crescent
Norbury, London SW16 4NX

© Copyright 2000 P. Joan Crole

ISBN 0 9534955 0 7

Printed by:
ProPrint
Riverside Cottage
Great North Road
Stibbington
Peterborough PE8 6LR

Introduction

In the beginning was the word... and so began a communication that has served well throughout the centuries. But very early on also was the brush...the tool that depicted life. So many scenes... happy, sad, a celebration, a loss, all were recorded to be gazed upon and considered, if not always understood...

So the artist evolved, and made the contribution that enriched human understanding. Men and women who felt the urge through the medium of the searching canvas to sing the praises of God and His Saints, show the nuances of joy and sorrow, or depict the horrors of existence. This was to be their visual essay, an attempt which was executed to the best of their ability. the record they laboured to make.

Such a man was Robert Dumont Smith. A man born and brought up in a world that no longer exists. Much has now changed, and sadly not always for the better. Some call this progress, and no further comment is needed.

Robert Dumont Smith was a man of many facets, but his overriding interest and passion was art. Basically he was shy, although most people who met him would not have understood this. He had a pleasing personality, which tended to give a different impression. The fact that he chose to remain in a back-water, however, underlines what I have just said. He was kind, indeed gentle by nature... and like so many artists and others he loved cats. They were a part of his life.

I loved Robert for a long time, and he loved me in the same measure. The fact that we did not marry was, in the final analysis, my fault. I am always conscious of his love, and because of this I wanted to write the story of his life as far as I knew it, and relate his thoughts and feelings on so many things. He would, I know have approved of this, and also that much of what I have written is taken from his lectures, although largely put into my own words.

He often talked about writing a book about his life, but he never did. I have written his story in the first person, as though he were telling it himself, which of course, in a way, he is. The medium, however, of my own composition was necessary.

The last chapter in the book is written entirely by me, and I have attempted as far as possible to keep it in the same idiom. Sadly, by then Robert was no longer a part of this Vale of Tears.

How much or how little I have managed to portray another world and a life that enhanced it, is for the reader to judge. All I can say is, that I have tried.

P. Joan Crole

I would like to dedicate this book to my mother
with love and gratitude.

Contents

Illustrations

Some of the paintings do not, because of the quality of the photographs, really represent Robert Dumont Smith's wonderful use of colour and the texture of his work. They are included as a representation of his range.

With the exception of one painting by his father all the paintings and sketches in this book are by Robert Dumont Smith.

CHAPTER 1

The scene is set

Today is my birthday. There have been so many, and all of them different. Looking back on a comparatively long life, now it's the beginnings that seem so clear. A retrospect, but where the recent and not the past becomes clouded. As a small boy, life appeared to have been perpetual sunshine...but with always the dust. There was so much dust in the streets in those days, one just took it for granted. Handel Lucas, the artist, and my father's one time master, had painted a picture entitled 'Dust crowns all'. No one wanted it, of course, but then no one wanted any pictures in those days. That was the reason why Lucas, struggling desperately to support his family, had been forced to take in a few students, but I knew nothing of that, at the time.

I remember sitting on the doorstep and watching the people...so many different faces and none of them alike. There was a man, young then, who used to go by swinging his arms in the most outrageous fashion...it seemed extraordinary. Curiously, he went by not too long ago. I hadn't seen him for many years, but I still remembered him as his arms moved in the same way.

To the right of the shop was the last private house in the terrace. At least, it seemed private, with the front door always closed. Then, suddenly, it changed, and opened as a butcher's shop. On the other side was the general shop or, as it was then called, The Oil Shop, kept by a rather superior family named Coe. They had three daughters, none of whom ever went to school. Nevertheless, they were all extremely well educated. One was a most accomplished pianist, and another became the secretary of the Dickens Society. Before then, the

shop had been owned by a gentleman named Crocket, who had three brothers, known as Faith, Hope and Charity. Hope helped in the shop, and so did Charity. I remember going there one Saturday night, and helping too. This contribution to the weekly sales made me feel very important.

Next to them was a shop that sold fish. In those days, the ice cart came along at regular intervals, as this was long before the advent of refrigeration. It was drawn by horses, who would stand patiently while the dripping ice was unloaded. Two shops further along the road stood the sweet shop. I remember my mother taking me there in her arms one Christmas Eve, and looking at the crackers, coloured toys and a Christmas stocking. I was eighteen months old.

The old fashioned boot shop had boots and shoes hanging outside on strings. Next door to this imposing display lived Miss Foulds, a maiden lady, whose home was a dear little house with a garden now, alas, all swept away. She looked like Dame Ethel Smythe, the musician. Very advanced in her day, she liked discordant music which now passes for harmony! Incidentally, Sargent, the artist, did a charcoal drawing of her.

She used to come daily to my shop, and in a crisp voice would demand "Greenwich time, please", then, with a curt nod, go on her way. Although I knew her for years, she never possessed a watch of her own.

The last building in the terrace was a small primitive Methodist church, now no more. And, looking back, there always seemed to be the endless summer evenings, as one heard the devout sing their hymns. At the top of the road were some cottages, built curiously on the slant. These were the firemen's cottages, and the small Fire Station stood in front. It seems they were built in that manner so that the firemen, rushing out to answer a call, did not run into one another. I remember seeing the horse-drawn fire engine racing past with the white horses galloping like mad, and all the firemen hurriedly putting on their helmets. All now forgotten. A glimpse of another world.

At the top, where Cherry Orchard Road joins Lower Addiscombe Road, was a very large pond. Nearby stood the house of the family doctor, a man named Hobbs. Many years ago, this pond was covered over, and since that time a number of houses in the immediate vicinity have been, on occasion, flooded in their basements. Closed pond water has to come up somewhere, a fact apparently overlooked by

the zealous road makers of the time. But it is as you turn into Lower Addiscombe Road that the really interesting historical detail emerges. The roads branching out at either side are named after the foremost cadets who attended Addiscombe Military College, the forerunner of Sandhurst. Outram, Canning, Clyde, Nicholson and Havelock...these were cadets who distinguished themselves in the Indian Mutiny, and subsequently became Generals. In Havelock Road, a square building still stands, formerly the Riding School of the Addiscombe Military College.

Going back to those early days, I think now of my parents...with my father working like a beaver in the shop, gossiping to friends, or standing at his easel, painting. My father was always interested in painting, and should have been much more successful than he was. I say, without personal bias, that his work showed a lovely touch but, sadly, no one wanted his paintings. He had been born in America where my grandfather, a man of some mystery, was living at the time. Born in 1831, grandfather was both a business man and a traditionalist and, before he became deaf, a great lover of music. He saw that my father was educated according to his standards. Eventually, the family settled down to live in Brighton, and this was where my father spent most of his youth.

Along with certain other properties in Croydon grandfather owned the house where I have lived all my life. When he moved to Brighton, he turned this house into a shop and let it. Incidentally, it was the first house in the road to which this was done. Following his rather impetuous decision, he rented two shops in Brighton and moved into Montpelier Place, where he lived in some style. The shops were successful, one selling good quality antiques, the other secondhand furniture. My father, then a very young man, spent his time painting.

In those days, a certain Mr Witt owned a successful art gallery in the town. He also had a studio in Ship Street. Here all the local artists used to gather and work. Among them was a Dutchman, Abraham Hulk, and his son, also Jenner and Joseph Thors. They were all impoverished young men, working hard and hoping that one day their pictures would sell. My father, at the age of seventeen, had a picture accepted by the Royal Academy and the following year, had been working on a painting of roses. This was never submitted to the R.A., so he finished it in Brighton and took it along to Mr Witt, who

subsequently bought it. After that he commissioned my father to paint what are called in the trade 'pot boilers', all of which were sold in Mr Witt's gallery. These were happy years for my father. He was doing what he wanted to do, and was content.

Then, suddenly, as happens in life, everything began to go wrong. My grandfather lost his money. He had always been a gambler, betting heavily on the horses and, let down by the unpredictable nature of the sport, was forced to change his mode of living. The shops went, as did his income and home, and he had to return to this house, now also a shop, in Croydon.

Being a religious man as well as a gambler, he accepted these reverses without demur, even with a certain degree of fortitude. He always read a chapter of the Bible each day, and used to attend the services regularly at St James' Church. Incidentally, this edifice is now a listed building, due to its association with the Addiscombe Military College. Recently, however, it has been turned into flats. But here, in the early days, the cadets - marching from the College in close formation - would attend service. Grandfather rented a pew there but then, sadly, he became very deaf and could no longer hear the sermons, which distressed him greatly.

I remember, as a small boy, having to sleep in his bedroom. One night, in particular, remains vividly in my memory. It was a brilliant moonlit night but, as usual, there was a nightlight burning in the room. My grandfather got out of bed, and I saw him relieving himself in the chamber pot. Afterwards he stood silhouetted against the window, his white hair framing his head like a halo. I watched him stoop and kiss the Bible. There was a shadow across the ceiling...if only one could have painted it. It is a memory that has stayed with me throughout my life.

I also recall watching my father paint a copy of Constable's 'Glebe Farm'. I was either three or four and so interested that I bumped my head on the pegs of the easel!

I watched the picture grow, looked at the real sky and back to the easel and thought "they're just the same". That incident probably sparked off my interest in painting.

Not long after I found a few odd paints in the garden shed. There was also, among the rubbish, an old slate with a broken frame, so I assayed my first oil painting. It was a picture of the Pyramids with

some Arabs in front, and terribly crude. I put it in the garden and left it there, because I was disgusted with it. Discrimination came early, I was four years old.

Sometime after that my father took me in hand, and taught me the elements of painting. He explained Hogarth's line of beauty and grace. Hogarth was so impressed with that line that he had it engraved on his palette. In the celebrated portrait of Hogarth with his dog at his side, the palette is in the picture with the line engraved on it.

Hogarth also wrote a very interesting book on the analysis of beauty, a subject that has puzzled philosophers since the world began. What is beauty and who can define it?

John Keats said "Beauty is truth, truth beauty". Perhaps that is the best description anyone has ever come up with.

My mind begins to wander a little, and I think again of this house. Next door to Miss Foulds was a resplendent cinema, admission one penny. Here small children queued up, waiting for the door to open. Inside were wooden seats, with an aisle dividing them. Under the screen was a red curtain, and behind the red curtain stood a piano. On this instrument tender pieces were played for the love scenes, and violent music for Red Indian and battle scenes. On either side of the curtain were three buckets, with FIRE painted on them.

There was also a majestic commissionaire, over six feet tall. The children were frightened of him.

Even when the film was in progress, he would march up and down the aisle shouting "Don't bang the seats!"

One day, sitting in the front, I pinched my finger in the tip-up seat. I went home and after a little while my mother took me back, and I was able to go in without any extra charge. That was the sort of cinema it was. Although no longer a cinema, the little window that formerly lit the projecting room still remains.

People must have been very thirsty in our road in those days! There were five public houses, all within a stone's throw of this house...the Leslie Arms, the Surrey Arms, the Cherry Orchard, the Nag's Head and the Horse and Groom. A row of cottages stood next to the Cherry Orchard and they are still there, although now of course much improved. Not long ago, one could still see the plaque over them with the words "Park Cottages, 1838" in large letters.

The road opposite was Leslie Park Road. Who Leslie was no one seems to know. However, he must have been an important man. In this same road, near the Cherry Orchard end, lived a blacksmith. I would hear him clanging his anvil in the early hours...there was so much horse traffic in those days. On cold, frosty mornings there would be a queue of horses waiting to have their shoes roughened. One day the blacksmith lifted me on to a mule's back. It was very uncomfortable.

There were still one or two large houses left in the road, and when one reached the top and turned left, there was a long countrified lane that led to Shirley. Here and there, between large prosperous-looking houses with enormous gardens, stood empty fields ripe for development. All have been developed long since. At the side of Addiscombe Road was a rough shrubland, called Brick Wood. As children we were frightened of it...it seemed so sinister. Nevertheless, we frequently went there with a pleasurable sense of fear, coupled with the fact that we might be trespassing.

Then there was Aunt Mary. She would come to see us, a fact which was always exciting, because she gave me and my sisters a silver shilling. She was very proper, but always kind. My mother used to tell us that in the grounds of the Young Ladies Academy where Aunt Mary had been educated, stood a horse-drawn carriage. Here, the young lady pupils were taught how to get in and out of the carriage in the correct manner.

Such delicate refinements are completely forgotten today. Girls and men now fling themselves in and out of motor cars with no sense of deportment. Although I remember once there was an Eastern prince who had a Daimler car built so tall that it was unnecessary for him to bend his head when he stepped into it!

Far different from the low slung vehicles of the modern age. On the bonus side, however, motor cars have done away with so much cruelty to horses. I can remember seeing carriages, traps and coster carts coming home from the Derby at Epsom. They would all be travelling too fast, with the sweating horses pulling the carts, and then there was the pitiful sight of the owner's dogs running behind them.

On a lighter side, there was a character who used to walk through Cherry Orchard Road on a Sunday morning. Immaculate in a white laundered overall, he would be pushing a barrow load of toffee

apples. On Saturday afternoons he would reappear, this time with muffins, ringing a bell as he went along. Another costermonger had a pony trap filled with boiled winkles. He used to come down the road shouting something that sounded like "Abergel". It took me years to realise it was "boiled winkles"! And then there was the milkman. He would dole out milk with a measure, into your own jug. Later the milk would arrive on a float. This was a horse drawn vehicle with a milk churn on the platform, and just enough room for a man to stand to steer the horse. He was a large man, with a habit of leaning on the reins.

One day, my father reprimanded him, saying "You should not do that. Your horse has got a very hard mouth". In those days, I'm sorry to say, many people were very hard and rough on their animals.

It was 1912, and almost the end of those sunlit years, in which the country had basked for so long. Good for some, but not all. The long Edwardian summer had drawn to a close, and now George V was on the throne.

That year I can remember my grandfather rushing in and saying "The impossible has happened, the Titanic has sunk".

My mother, aghast at his words, cried "Great Scott". No doubt the strongest expletive she knew.

Hastening to reassure her, grandfather said "but all were saved". How wrong he was.

August 4th 1914 brought the outbreak of the Great War, now usually just referred to as the First World War. It was a war of incredible waste, mistakes and misery, which saw the demise of a generation of young men, in the flower of their youth and virility. Life for this country, probably the world, would never be the same again. I had been ill, and remember watching my mother put blackout curtains up at the windows. Not too long after, bombs fell on the other side of the road. The ceiling came down in the bedroom, and the downstairs windows were blown in. It was the first zeppelin raid on this country.

Next morning I went into my grandfather's bedroom, put my head through the broken glass, leaned out and saw the devastation. I was quite excited and ran downstairs, had breakfast, got out my scooter and went outside. Buying a penny worth of sweets, I ate them as I scooted along.

The houses had been severely damaged in Stretton Road. There must have been a stick of bombs dropped by the zeppelin. One

had fallen in the school playground, and another close to the one in Stretton Road. On another raid, over Cuffley in Hertfordshire, a zeppelin was hit and in flames. I remember seeing a picture of airmen running along the top of it.

Curiously, the night of the first raid was my parent's silver wedding anniversary. They had been married in 1890. The family doctor, more concerned than his modern counterpart, had called to see if everyone was all right. In spite of the horror, the event became a social occasion. Later, my father fetched wood from the timber yard, and nailed it over the broken glass in the downstairs windows.

In those days, one of my sisters performed in amateur theatricals, and in 1916 sang on the stage at the Queen's Barracks. She was given a great ovation by the soldiers. The current popular song was "Row me on the river, row me Romeo". I suppose we could have been described as an artistic family. My father was a fine painter and a brilliant, if rather flamboyant, pianist. One sister wrote plays, and another played the piano from six thirty in the morning until bedtime and this, at times, was rather hard on the rest of us! I spent my time playing, painting and reading.

When, finally, the war came to an end, everyone thought it was going to be the beginning of a new age. Lloyd George, without doubt the architect of the Allies' success, talked about making the country fit for heroes to live in. It became a catch phrase, and was bandied about in an almost childlike belief in its possibility. Everyone thought it must be so and, suddenly, all things from the past were swept away. Hail to this bright new world, and away with the sentimentality and pomposity of the Victorian and even the Edwardian eras.

The Twenties was an extraordinary period. I was just a boy, but was caught up with it like everyone else. My eldest sister, now working in a film distribution centre in Wardour Street, was a prime example of the changes. She would come home filled with new ideas, and incessantly demanded that the best room, as it was called, should be "done over". Our parents indulged her whim, and decided to give her a free hand.

The result was that grandfather's balloon backed chairs with beautiful carving and slender cabriole legs were thrown out into the garden. Looking back, I remember how sad they looked. Eventually a rag and bone man came and took them away. The walls were stripped

of pictures, and instead of the scenes I had loved since childhood there was nothing now but an aching void. There had been a large picture of a snow scene, copied by my father from Koek Koek. In the picture, with its beautifully drawn trees, there was a man walking along a path. I had admired it since I first took an interest in painting. But it was taken down, and I never knew what became of it. The only picture that remained was a large still life picture, which father had painted when he was seventeen. I had it all my life, and only recently sold it to a friend. The rest were all thrown out, and forgotten. It was so sad.

Also in that room was a fine ormolu clock, typical 1830s French style, with classical figures supporting the clock itself. As children, we called it the angel clock. Sad to relate, this went the same way as the paintings. This was the period, difficult as it is now to believe, when people threw out fine glass chandeliers, and in their place put a piece of flex with a bulb at the end of it. They thought they were going 'modern'.

The moral is, of course, that every period is intolerant of the previous one. There is nothing new about this. It has gone on for generations, and can be illustrated by something that happened quite recently. Speaking to a student of the Royal College of Art, the young man said to me "You know, the College was terrible thirty years ago, but it's really fine today". Students have always talked like this, but sometimes the reverse situation applies. One recalls, for instance, the aged artist William Powell Frith, of 'Derby Day' fame, when he was being wheeled round the Royal Academy Exhibition by a friend in the bath chair he was now forced to use. ·

Looking at the paintings he said "It seems to me there is a lot of bad painting today". I sometimes wonder if he was right. I remember talking to the senior master of the Croydon School of Art on the same subject.

During the conversation I said to him "Have you been to this year's Royal Academy Exhibition?"

"No" he replied, "I have to see so much bad painting all the time. Why should I go out of my way to see any more?" It was obvious he did not approve of a black square on an orange square, or a mass of anonymous smudges entitled 'Composition' with the addition of whatever was the relevant year.

9

There is, of course, an incredible amount of self deception with some contemporary painters. Unlike scientists, who carry out experiments which are then stored for future research, many of these painters market their experiments, and I'm sure they don't know whether they are good or bad.

Some of the large commercial galleries exploit these efforts for business reasons. In my young days, my father took me to the art galleries, as a guide and mentor to what is right and what is wrong. As the years go by I realise, however, that he wasn't infallible. For example he stood, on one occasion, in front of Sargent's double portrait of the Wertheimer sisters. Wertheimer, financier and art dealer, had commissioned this series of portraits of his family from John Sargent. Incidentally, they have a gallery all to themselves in the Tate Gallery.

I was about sixteen when I first saw this series of portraits. I remember how, on seeing the double portrait of the sisters, I was absolutely bowled over by the brilliance of its technique. Life size, these two beauties stood...exquisite and timeless. At the side of the girls was a large oriental vase. My father deprecated what he called the 'sketchy way' this vase was painted. In fact, he said the whole painting was far too slick.

To me, however, the penetration of these two personalities far outweighed the somewhat summary treatment of the large vase. Today, of course (and sadly, I think) the art of John Sargent is denigrated. Nevertheless, he was a very great master.

Father much preferred Poynter's work...particularly 'A visit to Aesculapius'. It is a typical academic painting of nudes, brilliantly executed by the young Poynter, who for some time had been a pupil of Lord Leighton.

Personally, I prefer the nude paintings of William Etty, one of York's most famous sons. This, despite John Constable's sarcastic remarks, on seeing Etty's painting 'Youth at the Prow and Pleasure at the Helm'.

Writing to a friend Constable, often a taciturn and always a difficult man, observed tersely "They're all going mad about Etty's bum boat". Obsessed with the nude, Etty is probably the greatest painter of the nude this country ever produced. He went to Italy, and the Italian artists of the day are supposed to have described him by saying "He paints like an angel, with the fury of the devil".

Talking of Constable, one wonders whether his art would have developed so magnificently if he had not seen the two large Rubens paintings 'The Chateau de Steen' and 'The Rainbow'. Both are in London, one in the National Gallery and the other in the Wallace Collection. They obviously pointed Constable in the direction he was to go.

These hypothetical questions are always of interest. When Goya was painting the Duke of Wellington, the Iron Duke criticised the portrait. The enraged and excitable Goya is supposed to have picked up a pistol, and brandished it in front of the Duke. In the nick of time, Goya's son came running into the room, remonstrated with his father, and snatched the weapon away. Who knows whether Goya, had he not been stopped, might have shot the Duke, and then there would have been no Waterloo.

There is no doubt, if Napoleon had triumphed, that the pages of history would have been very different. As it was, it proved a hard won victory.

The Iron Duke, speaking later of the battle, admitted "It was a very near thing, and only I could have done it".

With hindsight, however, Napoleon had some very bad luck. His artillery was bogged down in the mud and, hard as it is to believe, a supporting army lost its way!

On the night before the battle, in an ante room at the Duchess of Richmond's ball, the Duke is supposed to have said "I will stop him here" and with a flamboyant gesture drew a circle on a large map round an unknown village named Waterloo. And quietly, one by one, the officers left, so as not to cause too great a disturbance.

As the ballroom became more and more deserted, the Duchess is also supposed to have remarked, with some understatement, "All this is going to spoil the dancing".

But when the news of the victory reached England, the whole country went mad with excitement. People literally wept in the streets. After decades of anxiety and despair, the shadow of Napoleon was finally lifted. To this day, it is still possible to see the round Martello towers along the coast, particularly on the cliffs of Guernsey and Jersey. From these towers, anxious eyes had strained across the waters for signs of an invading army. Now, that was no longer necessary.

At the time, one of the most successful artists of the day was David Wilkie, a friend of Collins, the painter. In fact, Collins named his son after him and in later years Wilkie Collins became the author of 'The Moonstone'.

With an eye to the main chance, Wilkie painted a fine picture entitled 'The Chelsea Pensioners reading the Account of the Battle of Waterloo'. Exhibited at the Royal Academy in 1822, it caused a sensation. It had taken Wilkie sixteen arduous months to paint, and contained sixty figures. The public flocked to see it, and so great was the pressure of the crowds that Wilkie was afraid the picture would be damaged. Consequently, he wrote a letter asking Sir Thomas Lawrence, President of the Academy, if he would arrange for a rail to be put around it. This was done before eight o'clock of the morning following Wilkie's request. Can one imagine such a thing happening today?

The Duke paid Wilkie twelve hundred guineas for the painting. He counted out the money to Wilkie himself in Apsley House. Afterwards Wilkie said that he told His Grace that he considered himself handsomely treated by the Duke, throughout.

The picture still hangs in Apsley House. A monumental work, it graces a stupendous collection, much of which had come to the Duke as the spoils of war. Inside the house there is a large statue. It was typical of the Duke, who was a magnanimous man, that it is a statue of Napoleon.

CHAPTER 2

Sir Edward Lutyens, horses and a painted ceiling

In 1929 I had my first picture accepted by the Royal Academy. It was inspired by a painting by Frans van Mieris which hangs in the National Gallery. He was a pupil of Gerard Dou, an artist whose work was noted for its high finish. The Mieris picture is a small cabinet sized painting of a young student holding a globe, surrounded by books and papers. It fascinated me, and I wanted to try and do something similar. My picture showed serious but pleasurable pastimes...a violin, artist's palette, books and pictures. It was called 'Companions in Solitude'.

After the Royal Academy, it was exhibited by invitation in many parts of the country. But, it did not sell. At that time paintings were generally very slow in selling.

Shortly afterwards, I had an illness which nearly proved fatal. After recovering from it, I became acquainted with Elliotts, the clock factory, in Croydon. This factory was next door to Gillet and Johnson, the bell foundry. Now, unfortunately, no more, only their large square shaped tower remains. Elliots, however, still thrives, and they always produced very high class clocks. Some of their grandfather or long case clocks had a moon dial at the top. Moon dials were used on clocks in the days when the roads were so dark that anyone wishing to travel by night, chose a moonlight night. The moon dial told them when there would be a full moon. No doubt, this was very useful with so many highwaymen about. Some people like to see moon dials on modern grandfather clocks, and in my twenties I painted many for Elliots.

Later, they were commissioned to make the magnificent clocks for the Vice Regal Lodge in New Delhi...shades of the British Raj. The Vice Regal Lodge was designed by Sir Edwin Lutyens, President of the Royal Academy, and our greatest architect since Wren. All the clocks had to be decorated to match the colour schemes in the various rooms in the Vice Regal Lodge, and all were made of teak, to withstand the ravages of insects.

It was a pleasurable experience to meet Sir Edwin...sometimes in Bolton Street, sometimes in Eaton Square. He was a fascinating man with an impish sense of fun. I can see him now, with his hands in his jacket pockets, smoking a little concert pipe, as he walked from one assistant's drawing board to the next. He would stop at each one, and discuss the drawing that was being produced. There would be a concert pipe on every assistant's drawing board, and these pipes were constantly going out. Sir Edwin would light them with a match, and lay each match by the side of the previous one used. Sometimes, there were a dozen dead matches at the side of the pipes.

I think David Jagger was his favourite sculptor. The famous Artillery Monument at Hyde Park Corner to the memory of 49,076 men of the Royal Artillery killed in the First World War is the work of C. S. Jagger. One day, while we were in the office, Sir Edwin telephoned Jagger, and they had a commercial conversation concerning the price of a statue for some Indian Potentate.

I heard him say "Well, I don't know if he is willing, but I'll try and get him up to an equestrian statue". An interesting sidelight on business invading art.

On another occasion, while discussing some work with a client who was sitting opposite him, Sir Edwin made a drawing of an equestrian statue which was upside down. A really remarkable man.

He was very interested in mouldings on buildings. One day he took a piece of paper and drew various mouldings for me, at the same time telling me their different names.

"Now", he said, "that is a Cyma Recta, that is a Cyma Erecta, and the next one is a Cyma Reversa". He went though them all...a Cavetto, a Taurus, etc, etc. Had I realised, I would have kept the piece of paper and asked him to autograph it. As it was, I took it home and lost it.

And a mark of his humanity...on one occasion, in the middle of discussing various things he suddenly said, "Oh, I must have a pee".

I looked up and, as he went from the room, he turned and said "Do you want to do one?"

At that time he was engaged on a design for the proposed Catholic cathedral in Liverpool. It was to be Christian bulwark against Bolshevism. But, due to the enormous cost, and the troubled state of the world that existed before the Second World War, the design was stillborn. Still, there was the finished model of the cathedral on a table in his office.

The Catholic cathedral that was eventually built pales into insignificance when compared to Lutyens' lost masterpiece. To me, this is a sad comment on the economics of modern society.

On the other hand, Gilbert Scott's Anglican cathedral in Liverpool is a fine example of Gothic architecture. Scott won a competition for the design, when he was twenty one. It took many years to build, and has not been all that long completed. Liverpool also has St George's Hall, a fine classical building inspired by the Parthenon in Athens.

It is many years since I was in Liverpool, but at that time it had a peculiar Victorian look about its waterfront. Some of the side roads reminded me of Lowry's Salford. One of my favourite excursions was by overhead railway to Birkenhead. This also, now, a thing of the past. At Birkenhead is the Leverhulme Art Gallery which contains fine art treasures, including 'Isabras at the Ford' by Millais. Another fantastic painting is the 'Daphnephoria' by Lord Leighton. A religious procession, Holman Hunt called it the most beautiful picture in the world. Something of an exaggeration perhaps, but such was his enthusiasm for the painting.

Also, I remember the beautiful collection of porcelain, particularly the Wedgwood, in the gallery. There is an embarrassment of riches. Lord Leverhulme, incidentally, had his portrait painted by Augustus John. He detested it, and when he sent the extravagant cheque in payment to John, he also sent back the canvas, minus the head. This he put in his safe!

It is of interest to note that there is also a small picture by Handel Lucas in the gallery, called 'For such is the Kingdom of Heaven'. During that trip, I visited my sister in Crewe. There was an

enormous slag heap like a mountain in the district, and a man working there. I asked him if it would be possible for me to go up this gigantic pile.

"I wouldn't advise you to," he said, "it's possibly very hot". I made a painting of it, however, because it reminded me of some of the industrial landscapes painted by Sir Charles Holmes, sometime Director of the National Gallery, and a fine art scholar.

Talking about Liverpool reminds me of a conversation I had with Sir Edwin Lutyens concerning the English genius Alfred Stevens. In fact, it was that which made me look again at the work of Stevens. His greatest masterpiece was, undoubtedly, the monument designed for the Wellington Memorial in St Paul's Cathedral. Born in the village of Blandford in Dorset, the son of a painter and decorator, he became, possibly, the most educated artist this country has ever produced.

When quite young he attracted the attention of art lovers in Blandford. They, realising he was something rather special, subscribed the sum of sixty pounds for him to study art. One of the principal interested parties was the local vicar, a man named Best. Best decided to see whether Sir Edwin Landseer would take this young boy as a pupil. Landseer was one of the most popular artists of the day and, indeed, gave lessons on sketching to Queen Victoria. However, much to the disappointment of the Reverend Best, although a lucky escape for Stevens, Landseer wanted three hundred pounds to take him as a pupil. As this was far too much, Best suggested that the boy should go to Italy, and study the work of Salvatore Rosa. So, at sixteen Stevens was packed off to Italy on his own.

Now, this is where genius steps in. He was quite alone, and yet by some instinct, he looked at all the great masters. It is evident that he soaked up their genius as he went along. Instead of the 'Dignity and Impudence' of Landseer, Michaelangelo and Raphael were pointing the way ahead.

The struggles of the young Stevens must have been severe. He eked out a precarious living making pencil portraits and, as often the practice in Italy, made himself useful in some of the art studios. We know that, eventually, he became an assistant in the studio of Torwaldson. He must have been tireless in his studies. Altogether, Stevens' stay in Italy lasted a little under ten years, and after this time he

came back to England fully equipped as an artist, sculptor and architect. Sadly, though, this country never knew what to do with him.

An architect, Leonard Collmann, gave Stevens various commissions for designs and, as an example of his amazing versatility, he painted a portrait of Mrs Collmann. This is one of the great portraits of the nineteenth century. Sir Charles Holmes said that it could hang beside a Raphael and hold its own.

The Wellington Memorial in St Paul's Cathedral, Stevens' masterpiece, was the winner in a competition for a memorial to the Iron Duke. However, the difficulties he encountered, including interference by several committees, make for sorry reading. Eventually the memorial was completed, with the exception of the equestrian statue at the top. Stevens died and it was completed by his pupil, Theed.

Another facet of Stevens' versatility was when he designed stoves for a firm who, I believe, subsequently received a gold medal for the work he produced for them.

Theed, like his great master, executed work for the 1851 Exhibition, and there is no doubt that the Exhibition proved a great encouragement for art and industry. It all started with a talk between the Prince Consort and Henry Cole, the latter a man of great energy. I think he designed the first Christmas card, or was that the work of Horsley? Yes, now I remember, it was Horsley and the year was 1843. Horsley was an interesting painter - and very fond of name dropping. Read his autobiography, it is filled with names of the famous people he had met!

I particularly enjoyed his story about Isambard Kingdom Brunel. When Brunel was building the Clifton Suspension Bridge, the car he was riding in seemed to get tangled up with overhead cable. Brunel actually stood on the edge of the car in order to disentangle it, with the great drop beneath him. One shudders to think of this incident, but Brunel was a man of great courage allied, in some way, to his amazing engineering conceptions.

He was very interested in the Atmospheric Railway. It is easy to understand how this brilliant idea intrigued Brunel, but nobody envisaged the rats eating the grease on the track. This accounted for the railway's failure.

The audacious engineering feats of those Victorian giants are remarkable. Take for instance the stupendous achievement of the

Crystal Palace. From a small doodle that Paxton made on a blotting pad in front of him, came that fantastic glass palace. The name Crystal Palace was suggested by the magazine Punch.

Originally in Hyde Park, it ended in the great fire at Sydenham in 1936. Nobody thought it could possibly burn...it was all glass and iron. I vividly remember many happy hours spent wandering in the wonder that was the Crystal Palace. As a small boy I had sat, entranced, listening to someone on that mighty organ playing 'The Lost Chord'. Unfortunately I never heard the Handel Choir, another great feature of the Palace, but know that when they sang the 'Hallelujah Chorus' everyone present went into shivers of ecstasy. How is it, one wonders, that a tremendous creation is sometimes conceived and produced during great suffering. One of the mysteries of life, I suppose. While composing the Messiah, Handel was struggling against insanity and blindness.

The Crystal Palace, steeped in nostalgic memories, evoked so much that was good in the Victorian era. I still have a Prattware Pot lid, with the beautiful edifice printed on it. It was tragic it all had to end in that disastrous fire.

I've mentioned Handel Lucas before. His father was a singer, in fact I believe he was a member of the Handel Society. That was how his gifted son got his name.

Croydon had another musical composer...Coleridge Taylor. In the Fairfield Halls was a portrait of Taylor which I restored for Michael Terle, its former manager. This portrait used to hang in an annexe to the entrance hall but I understand it has now been replaced by a photograph of the composer. The official biography of Coleridge Taylor was written by Berwick Sayers, one time chief librarian of the Croydon Libraries. A charming man, Sayers was frequently asked to open various functions in Croydon, and could always be relied upon to make a graceful speech.

Another friend of mine in the libraries was Kenneth Ryde, the senior librarian, who I believe had been in the cavalry during the First World War. I am going back many years now, and although nothing came of the idea, he did discuss with me the possibility of my painting an equestrian portrait of him.

I was also fond of riding, and can remember taking a horse out one night. It was a lovely summer evening, and I fancied a ride. I went

to the riding stables, and they lent me a mount to go for a ride in the country around Warlingham. I was enjoying myself very much when, suddenly, something upset the horse. Either he was stung or something else startled him, but he put his head down and bolted. We were crossing a large field at the time, with very long grass. It must have been a paradise for courting couples, because as we went along at a mad gallop, a couple here and a couple there would jump to their feet in consternation! The grass was so long you couldn't see the lovers and as I went by, disturbing them, they were completely disorientated.

Eventually, I managed to pull the horse up at the end of the road. He then reared up, and threw me.

I remember thinking "This is where I'm going to break my collar bone", as my left shoulder hit the ground hard, and my feet went up in the air. However, I was fortunate, and picked myself up to find there were no bones broken.

The horse went galloping down the road, and I jumped on a passing van. Luckily, the horse eventually ran into a meadow next to the stables, apparently none the worse for his escapade. The following night I went back to the stables, and took the horse out once more. Perhaps I wanted to see those hidden lovers again!

There was another incident with horses, this time on a more sober note. I had brought a new overcoat and, this particular evening, put it on and was showing it to my mother and sister. We had an odd job man named George, who was doing some small repair in the bedroom.

Suddenly he came running down the stairs crying "The stables are on fire!"

Instantly, I ran out of the back door, across the gardens and along the alley towards the stables. Flames were licking round the side of the great door. I put my shoulder to it and it burst open. The heat was so great, it started smouldering the garden gate on the other side of the alley.

There was a stampede of hooves, and I caught one of the horses by its bridle, and ran my hand down its back. The poor creature's hide was all scorched, and its tail came off in my hand. Next morning, it had advanced pneumonia and had to be destroyed. Mucus was hanging down a yard long from its nostrils.

Another horse in the stable reared up as I went towards it, and ran back into the flames. By this time the fire brigade had arrived, and they played their hose on this animal. It was an appalling sight. The following morning I went to see the stable. All that remained was a charred wreck, and there was the body of a horse, or rather, just the barrel. The legs had been burnt away. My little dog who was with me, went up to it, looking at it with lowered head. Then, he let out a long, dismal howl.

There was an account of the fire in the local paper, and a sensational story about workmen at the stables trying to get the animals out. This was untrue, for there had been no workmen there, only myself and my brother-in-law, who had later tried to help. He did get a kick in the ribs that required a hospital visit. As for me, my eyebrows were singed, and my lovely overcoat was ruined.

Today there are no horses, and the sheds are long gone. In their place stands a large hanger, designed for modern industries. But, for years and years, it was a cobbled yard, sloping down to a drain in the centre, and surrounded by the stables.

On entering the yard, the first thing one saw was the manure pit. The first stable was the harness room. Then came the stable rented by Mr Richards, the greengrocer, that housed his wagon and van. And next was his patient horse, a typical 'vanner'. The stables went right the way round, and in one corner stood the remains of a separating plant. This was a legacy from the time when the yard had been a dairy.

Years ago there was a long low stable next to that which had had the disastrous fire. At the time I am talking about, there was one horse in it. In the early days of the war, this stable suffered a direct hit. The bomb shattered all the windows in our own house, and brought the ceiling down.

The lights went out, and I remember saying, somewhat fatuously, "I think we've been hit". I went outside, and found the concrete shed in the garden also demolished by the blast. Our next door neighbour had had a bombproof shelter built in his garden.

He was not living there at the time so, very considerately, had said "You can always use this shelter, if you want to".

Luckily we did not use it, because it was now a shambles of concrete block, and if anyone had used it, they would have been killed.

I walked over the debris of the shed in our garden, through the gate and into the alley again. The long low stable I have already mentioned was a pile of broken bricks. The lonely horse who lived there was standing in the rubble with only his head visible above the bricks. I started to pull the bricks away when I heard the footsteps of someone walking down the alley.

A man whom I had never seen before, nor since, said in a cockney voice "Blimey, is he still alive?" Walking round the side, he continued, "I think we can get this steer out".

A curious term for an Anglo Saxon to use.

By this time we had cleared the bricks from around the horse's legs. Miraculously, he seemed to have suffered no injury. The stranger caught hold of the halter, and with a pull and flurry of dust and bricks, we got the animal out.

We looked at one another and I said "What shall we do with him?"

There was a moment's hesitation and then my new friend said "I know, we'll take him to the stable in Leslie Park Road".

At that time, the Co-operative Society was stabling a few horses there. We found an empty stall, and left the horse. It was about two in the morning.

The following day, going out to survey the previous night's damage I saw Mr Goddard, the owner of the yard and the butcher's shop. He was looking at the devastation.

I said "What a night".

His only reply was "We don't know where the horse is". I told him where we had put it, and one of his men went round and fetched the animal.

When the war was over, it was thought that there might be an unexploded bomb nearby. I suppose the devastation that had taken place at the stables had not been severe enough for a large bomb. One day, an army bomb disposal team arrived, and started digging. Going outside, I was surprised to see them, and asked what they were digging for.

Looking at me in a bemused manner, a soldier replied "We think there's a bomb here".

They dug for some time, and made a very large hole. Then, evidently, they lost heart, and stopped. One very interesting detail,

however, came to light, and this shows how certain things can be forgotten with the passing of time. While digging for the bomb, they uncovered the foundation of a large building. This foundation was much larger than anything needed for a domestic dwelling, and I thought it could have been for a mansion or stately home. It probably was, because from a fairly recent letter published in the local Guardian, it seems that in about 1825 a house named Leslie Lodge was built on the west side of Lower Addiscombe Road, between what is now Cherry Orchard Road and Cross Road. It had been covered for so many years and now, as the soldiers filled the hole, it was lost forever. I used to wonder if the place was anything to do with Leslie, after whom so much is named around here. Leslie Grove is at the top of the alley, and opposite is Leslie Park Road. Just above the Cherry Orchard public house stands the terrace of houses, now much smartened up and selling for quite high prices. These were, as I mentioned earlier, originally workmen's cottages. As I have also previously said, there was the public house - the Leslie Arms.

Just before our house is Cross Road, which originally joined up with the old Croydon Common. The latter became obsolete when the Windmill Bridge was built. At the top of the bridge, you turn right down what is now Gloucester Road. This road was always referred to as "across the common". It is interesting to think that what was once common land is now owned by a variety of people.

Coming back to the top of Windmill Bridge, you look down on an area called Bridge Place. This was an enclave of small cottages, and years ago the Croydon Pest House was situated there.

The Pest House was a primitive isolation hospital, where smallpox cases were taken. A lady named Mrs Axford, who presumably ran the hospital, lived there with her children. These details were told me by an old man, now long since dead, who said that as a boy he had played with his friends in the ruins of the Pest House.

When my father was about fifteen he painted a picture of the Pest House, which I had for many years. It was a remarkable piece of work for someone so young but, sadly, not long ago it was stolen in an appalling burglary. While my father was painting it, his mother sat by his side, because she was frightened that the hooligans of the day would upset him.

At the top of Cherry Orchard Road was open country, which went as far as Shirley and Wickham. Wickham is built up now, but when I was a boy it was a country village. There was a great house on the site alongside the Swan public house. The pub is still there.

The house was the home of the Mellins family. Their name could be seen many times in various magazines, advertising Mellins Baby Food. As a boy I visited the house, and was amazed at the opulence of the furnishings. In the servant's hall about fifteen or more servants sat down to a meal. They were supplied by the local butcher. The other house in Wickham belonged to the North family, but I never knew anything about them.

Where the Mellins' residence was is now a parade of shops, including Woolworth's and other well known firms. Another example of a rural vicinity being turned into a shopping centre. At the end of the High Street is the Swan, and turning left you would be on your way to Beckenham.

The 54 bus would go along to Catford and Lewisham, and it was in Catford that I met my dear friend Captain Moller. He had had a distinguished career in the First World War, and on demobilisation started an antique business in London. In some early issues of the Connoisseur magazine there is his advertisement...Captain Moller, Fine Art Dealer, or words to that effect. I recall one advertisement of his which included a sculpture, one of his greatest 'finds'. He sold it at a reasonable price. Eventually, however it was identified as one of the maquettes by Michaelangelo, produced as one of the slaves on the tomb of Pope Julius II. This is now in the United States, in one of their great museums.

Through Captain Moller, I was called in to restore a painted ceiling in Lewisham. The ceiling was in a large house - I suppose one could call it a mansion - that had been the residence of a doctor many years ago. One of the reception rooms was a circular chamber supported by Ionic columns, which were a kind of snuff colour with gold enrichment. Above was a coved painted ceiling.

The last inhabitant, probably the doctor just mentioned, had lit the room by a gasolier. The heat from this gas light had blistered the paint in the middle of the ceiling and, obviously, every time the house had been decorated in the past, the decorators had coated the ceiling with varnish.

Sometime before the Second World War, when I was called in for an appraisal of the necessary work, I found on looking up, that the ceiling was a dark brown with the details almost obscured. I made my report, and was subsequently asked to restore the ceiling.

At this time, a wealthy greengrocer was negotiating the lease of the building and Captain Moller had been called in as the expert for the subsequent refurbishment. It was a noble residence, with a spiral staircase that led up from the entrance hall to a kind of skylight belfry. From the skylight was suspended a bell, which, if I remember rightly, was dated 1751.

I arranged with Captain Moller to have a platform erected under the ceiling for me to stand on and I started work. It was an arduous task.

As I removed the discoloured varnish, the treacly substance ran down my hands and wrists, so I was soon wearing the oldest clothes I had whilst engaged on this difficult work. What made it all worthwhile was the sudden realisation of the brilliant colours that emerged with the removal of the varnish. Colours that had been locked up inside this dark covering for centuries.

The principal decoration of the ceiling was a large garland of flowers. Springing from this garland, the ceiling was fluted up to the apex. When completely cleaned the result was brilliant, and the colours leaped out at me in a most glorious and satisfying manner.

All this, as I have said, was before the Second World War. Then, following the outbreak of hostilities, the house suffered from bomb damage. I was called in by the firm repairing the damage, and asked to go and look at the ceiling. It was a sorry sight. The obscenity of war had caused ninety per cent of the ceiling to be shattered. All that remained of that part were the laths looking naked against the rest. I told the builders that the first thing to be done was to re-plaster the ceiling where damaged. Then, they must paint it a dark slate colour ready for subsequent decoration. It was a job I was not looking forward to, as I knew how difficult it would be.

After about two months, the builders telephoned and asked when I would be coming to start the ceiling.

I said "I will be there before long". But I had no idea when I would go.

After another lapse of time, the owner of the building firm telephoned and said "My client is getting a little fed up waiting for you. In fact, he is tired of walking about under the scaffolding".

I apologised for the delay, and said I would start the following week.

They had erected the usual platform for me to work on. I took my paints and mixed up a certain colour, then applied a touch of it to the damaged part of the ceiling. When I came down from the platform and looked up at the work, my touch of paint looked no more than a pin head.

Climbing up again, I put a few more dabs of paint round my first effort, and did a little more work in a very hesitant manner. Then I remember thinking to myself that I wished the Master who painted the ceiling was looking down at me now. And, suddenly, with a new bout of energy, I started to work.

I am not interested in psychic experiments but must admit, from that moment, the restoration of painting the ceiling proceeded in a fantastic way. Feeling elated, I descended the ladder and looked up. I could not see where my painting began, and the original painting ended. The ceiling was completed by a coat of a refined copal varnish bought from Winsor and Newton's. The job was finished.

I really must go and look at it again one of these days.

CHAPTER 3

The Royal Academy, £100 and my new coat

A stone's throw away from that house was Captain Moller's home, where he lived with his mother and sister. I enjoyed my visits to his house, because we used the same jargon and talked about antiques and painting.

The room I especially loved contained a concert grand piano. On it was a plaque, telling all and sundry that it had been presented to Sir Charles Hallé. It was a magnificent instrument, and whenever I went there I always played on it. Sometimes I took my musician sister with me, and we played duets.

Sadly, the war finished all that. Captain Moller had a position in the War Office and so, obviously, much of his time was spent away from home. One day, during an air raid and while he was in London, a bomb fell on his house. It killed his mother and his girl friend, and shattered his home.

I lost touch with him after that. I suppose everyone had certain things to do, and our friendship was not renewed until after the war.

I was invited to have an exhibition of my paintings in Foyle's Art Gallery, in Charing Cross Road. There was a flattering criticism of my pictures in the magazine Art Review, and I found that one of the paintings had been bought by Captain Moller. And so we resumed our friendship.

This was just after war, and I had started painting again. War work precluded any painting during that time, with the exception of some scene painting for an amateur theatrical production with which I was involved. Through this scene painting, I became very interested in

amateur theatricals. We performed the usual run of productions. One I remember was Terence Rattigan's 'Flare Path'. Shortly after that we put on another production, and although I can't remember what it was, there was a very good review in The Stage.

By this time I had also renewed my business of clocks and watches. Although I was now painting seriously, the latter had to be relegated to what was more or less a spare time occupation. But, in 1949, I started on a picture that I wanted to submit to the Royal Academy.

The only time I could work on it was after I had closed the shop. I would paint from about eight p.m. till midnight. My evenings were taken up with the production of this picture, and as it progressed the sessions grew longer.

I must admit that the picture went along very well, but it was taking longer than I expected, and receiving day for the Academy was getting perilously close. By this time I was working until about two a.m., and on the night I finished I laid down my brushes at three fifteen. It was done. The next evening, as a relief from all this painting, I went to the cinema. I had no television myself - indeed, few people did at that time - and films made a pleasant change.

On the following Saturday morning my friend Miles Meehan came in. He said he was taking two pictures to the Royal Academy, and asked if I had anything to submit. Although I had completed my painting with the idea of sending it to the Academy, what with running my shop during the day and painting at night, I had forgotten to send away for the forms for the Exhibition.

The picture was on the easel when Miles came into the room. He said "You must send it...it will get in, for sure". What an optimist Miles always was.

When I told him that I had forgotten to send for the forms he said "I've go another set in my bag...how much are you going to put it in for?"

"Oh, I don't know. About thirty pounds, I suppose".

"Don't be silly" he exclaimed. "Let's say a hundred". In 1949 one hundred pounds seemed a colossal amount.

About three weeks later Miles came in and said his picture had been rejected.

He named other members of the coterie and said "They've all been rejected".

"I've not heard yet" I said and Miles replied "You must be in...you're the only one".

Shortly after that I received the magic varnishing ticket, saying my picture was hanging in the Academy.

I felt quite elated as I went to the Academy that particular morning, rubbing shoulders with celebrated artists. Sir William Llewellyn was President of the R.A. that year, and there was Davis Richter, in an orange shirt, talking to him. Meredith Frampton was also there, with a very, very beautiful still life. I admired it enormously - he was signing the work as I looked. That picture now hangs in the coffee room in the Academy.

The Tate Gallery gave Frampton an exhibition of his beautiful work, just a few years ago. I always remember his wonderful portrait of the Bishop of Exeter, sitting benignly in red ecclesiastical garb. When he died the R.A. tardily exhibited a few of his pictures in a side gallery. I suppose his work is out of fashion with the prevailing tone of the Royal Academy today.

You will recall what I related about Frith, and his remarks concerning bad painting. Unfortunately there is still a lot of bad painting about. So many artists have completely forgotten nature, and produce large experimental work, which attracts notice because of its strident style. However, the traditions of the Academy are very strong, and when we think of the past masters, I suppose it will weather the storm.

After all, the Royal Academy has been thriving since the days of George III. Founded in 1768, Sir Joshua Reynolds became its first President. Not only was he the finest portrait painter we've had, but he also possessed a rare literary gift. The discourses which he gave his students at the R.A. are works of untold gold, although it's true that his admiration for Michaelangelo wears a bit thin after a time. One cannot always paint in the manner of the work executed in the Sistine Chapel.

Sir Joshua earned a good living painting portraits, and not trying to copy Michaelangelo's mighty conceptions. He compromised, for example, by painting Mrs Siddons' portrait, which you can see in the Dulwich Gallery, where the great actress is seated on a throne, in a manner which recalls one of the Michaelangelo prophets on the Sistine

Chapel ceiling. In this picture she is supported by two figures at the back of the throne - one representing tragedy, the other comedy. It is said that when Mrs Siddons went to his studio for this portrait, she sat on the throne and looked at the pictures on the wall. Sir Joshua Reynolds seized that moment and, if you consider the picture, her face has an enquiring look, as though that is exactly what she was doing.

The picture is, of course, in poor condition now, because of Reynolds' pernicious use of bitumen. Bitumen gives a wonderful glow to a painting when first applied, and it was a quick way of getting the glow we see in a Rembrandt portrait, but it never dries. This results in deep fissures and runs, which causes havoc to the painting. I believe it was Hilton, sometime keeper of the R.A. who, after painting a picture of the finding of the body of Harold after the Battle of Hastings, used bitumen freely to give this glow to his picture. Today, it is just a wreck.

Sir Joshua sometimes mixed paraffin wax with some of his colours.

He seems to have been aware of his doubtful practices, because he is reported to have said, philosophically "All good paintings crack". Not really true, because a simple technique can last.

When we think of the portraits painted by his rival George Romney, whom Reynolds referred to slightingly as "The man in Cavendish Square", we see the evidence of this. Although no way nearly as clever as Reynolds, Romney's straightforward simple technique has lasted remarkably well.

George Romney, rather a neurotic personality, left his wife in Cumberland, and set up in London as a portrait painter. He proved a serious rival to Reynolds, although his art was nowhere near the same quality.

But he had his following, and a certain noble peer said of portrait painting "There are two factions in London...the Reynolds faction, and the Romney faction. I, personally, belong to the Romney faction".

Romney formed an infatuation for Lady Hamilton, who began her service to life as a nurse...one Emma Hart. Didn't she nurse one of the Linleys through an illness? That nest of nightingales forever immortalised in their portraits in the Dulwich Gallery. I digress, for a moment, to look a the portrait of these two sisters.

Their father was the manager at the Bath Assembly Rooms, and one of the daughters sold programmes to the audience. The other captivated them with her singing.

One of the girls married Sheridan, author of 'The School for Scandal'. Gainsborough painted the two sisters and this is the portrait that is in the Dulwich Gallery.

My first visit to that gallery was when I was about thirteen. My father had told me about the beautiful pictures there. It seems that years before he had gone with Handel Lucas, to look at the Van Huysums. He spoke of walking down College Road, and years later I did the same thing. This is a place where time stands still. In those days, you didn't enter the gallery by the main entrance as you do now, but round by the side, opposite the playing fields. It was rather a fusty experience then...going into the gallery, I mean. The place had a kind of musty look about it. There were no attendants, but a rail prevented you getting too close to the pictures.

I remember feasting my eyes on the Van Huysums, and marvelling at the Dutchman's incredible skill. Sauntering around looking at the other pictures, I thought about the mention of them in Ruskin's 'Modern Painters'. Ruskin had certainly studied these painters at Dulwich and, no doubt, they were the germ of his book.

Filled with admiration at the bird's nest in the Van Huysum painting, I decided I would attempt something like it. I remember cycling to Shirley and Wickham to find some primroses for this masterpiece I was going to paint. I had recently seen a beautiful painting of primroses and birds by William Hunt, and with the arrogance of youth thought I could do the same. But, there was not a flower in sight.

After a fruitless search, I plucked up courage to walk up the path of a small house, knock on the door, and to the amazement of the lady who answered it, ask, "Are there any primroses about here, please?"

She looked at me, then disappeared, and presently returned with a flower pot of primroses in full bloom.

She said, "Well, here's a root of them. You can have the pot for one and sixpence".

I only had one and threepence I said. She pondered for a moment then, with a generous look, agreed to let me have them.

I took the pot of primroses home, and put them on the table ready for painting. But by this time the light was beginning to fade, and it was too dark to start work. Never mind, I thought, I'll start tomorrow. Such is the aspiration and enthusiasm of youth!

Alas, next morning their pristine beauty had gone. I gave up the idea of this masterpiece, à la William Hunt. Quite recently I was looking through a Sotheby catalogue and there was a picture of a bird's nest by him with, not primroses, but May blossom. He had called it 'Emblems of Spring'.

It shows how my father's influence on me had been due to the early influences on him. If all this sounds very trivial today, one must remember the Wordsworthian sentiment of such pictures was more formidable in the days of Handel Lucas, or around about one hundred years ago, than it is now.

That style of art was very popular then, due primarily to the writings of John Ruskin. Ruskin looked upon the work of William Hunt - Bird's nest Hunt as he was called - as examples of real painting. This led to a number of artists, including Lucas, painting pictures of bird's nests. However, Sir William Richmond, sometime protégé of Ruskin, broke away from his influence, and eventually became a fine classical painter and sculptor.

Yet, on one occasion he did say "had I remained an imitator of William Hunt, no doubt that would have pleased Ruskin".

It was amazing the influence Hunt had on so many people. But much of his popularity was due to Ruskin's praise.

Thackeray is supposed to have said "Had I the money of the Duke of Devonshire I would have a William Hunt in every one of my rooms".

And it is a fact that the brilliance of his colours was quite extraordinary.

Technically, he achieved this by coating his water colour paper with a layer of Chinese white, then delicately painting his colours on top. I remember standing in front of one of his pictures in the Leverhulme Gallery in Birkenhead, and the luminosity was quite outstanding. I think, too, of the small bedroom of Ruskin's house, 'Brantwood', by Coniston Water in the Lake District. Around the walls in that little room were matchless water colours by Turner, but over the fireplace was a small still life by William Hunt. Possibly during those

storms that beset Ruskin's mind, he may have found solace by looking at this charming, unpretentious picture.

I once produced a small bird's nest painting, due to the influence of Ruskin and Hunt, but primroses were not a part of it. A couple I knew had a lovely garden, with two rows of apple trees down the centre of the lawn. In Spring, this garden was a thing of beauty with the delicate pink and white blossom.

Going there one day, I couldn't help exclaiming "What a lovely sight". Their garden looked just like a stage setting.

I asked the lady of the house whether I could have a sprig of the apple blossom. Her husband seemed a little hesitant...perhaps he thought each sprig represented a vast quantity of apples. However, he relented, and I brought the apple blossom home and tied some wet cotton wool round the bottom of the stem. I had a hedge sparrow's nest by me but, I assure environmentalists, I never went bird's nesting.

It was an old nest, and a few weeks earlier, quite by chance, I had bought a small cardboard box with some eggs in it. This was before the days when it became illegal to buy bird's eggs.

Among the collection were two hedge sparrow's eggs. I placed these in the nest, and with poetic licence painted them as four. In the picture the pale blue of the eggs was foiled by the pink of the apple blossom. Thinking of William Hunt, I used a mossy bank for a background.

There was a small exhibition of paintings by local artists in the Croydon library, and my picture was among those exhibited. Subsequently, I sold it.

I have been fairly successful exhibiting my paintings, but the exhibitions have not been financially rewarding. Four of my pictures were sold at the Royal Academy, but the two I thought my best were not sold there. These eventually went to a private buyer.

In fact, sending pictures to an exhibition is an expensive business. There is the transporting, and then the entrance fee. And, if you are lucky enough to sell anything, the gallery or organisers charge commission. There was no charge for my first Academy submission, but the fee is now quite high. Of course one must admit this does stop incompetently facetious works being sent in. Up to twenty thousand paintings can be submitted to the Academy, and when one looks at the

number actually included in the catalogue it illustrates how slender are the odds of being accepted.

As far as the Presidents of the Academy are concerned, I suppose one of the most glamorous was Sir Frederick Leighton. He was famed not only for his painting and sculpture, but also for his so called 'Arab Hall'.

Despite Ruskin's denigration - he called it 'Leighton's Aladdin's Cave' - it really belongs to the Art Nouveau Movement. The theme was the result of all the Persian tiles Leighton collected on his many wanderings. But, even then, there were not enough genuine Persian titles to complete the conception, and William De Morgan, the potter, was commissioned to make up the required number.

Eventually De Morgan was to say "From a business point of view, the price I charged Sir Frederick didn't pay me".

It is rather interesting to note that William De Morgan created a second reputation in life, as a novelist. Perhaps his most celebrated work here was 'Joseph Vance'. During the First World War a soldier read this book in the trenches and said afterward that if he survived the holocaust, he would make it a necessity to meet De Morgan. He wanted to tell him how much he had enjoyed the book. He did survive the war, and subsequently visited the author.

Unfortunately for William De Morgan, and unbeknown to both of them, the soldier was a carrier of trench fever. De Morgan contracted this fell disease. He did not recover from it, and his wife sat by the side of the bed as he lay in a coma. This was another tragic and sad result of the First World War.

Wars and battles have, inevitably, always taken their toll of human life. Past and present, both bear abundant witness to this, and the side effects have been just as significant. I have already mentioned the Addiscombe Military College, and the distinguished soldiers who served in the East India Company's army. This Company ruled India up to the time of the Indian Mutiny, one of the turning points in that remarkable continent.

When I was a small boy, my grandfather had a coat made for me out of a fine coat that belonged to his wife. I was almost five when he took me to a little terraced house in Warren Road, where a Mr Plummer was a working tailor. He was now an old man, but in his younger days had been a tailor for the East India Company. I felt very

grown up standing there with this very aged person measuring me. In the middle of the room was a large, low legged table, which tailors once used while sewing. I don't know whether they still do, but tailors used to sit cross legged on the tables, plying their trade. The coat he was making for me was very flattering, and I thought it looked most distinguished.

At that time, I was friendly with a boy some years older than myself, and remember one evening going with him to the Hippodrome which was down Crown Hill. We clambered up the steps to the gods...obviously the cheapest seats were up there. I couldn't quite see into the booking office, even on tip toe, and so Cyril, my friend, who was a few inches taller, placed the money on the ledge and bought the tickets. At the side of the booking office there was a giant of a man, the commissionaire.

As Cyril moved away the commissionaire whisked me off my feet and said, much to my annoyance, "Is it a boy or a girl?" This was in the early days of the First World War.

Grandfather also bought me my first cricket bat.

There was a nice lady teacher at the school I attended, and one day she said to me "There is a fine film at the Scala, 'Tanks in Action'. Would you like to go and see it?"

I told my parents that Miss Smith wanted to take me to the cinema. They said I could go, so she said she would call for me at half past six. I would wear my new coat.

She arrived on time, and must have thought it a curious household, because my grandfather lived in the middle room which later became my studio, and which was lit then by a paraffin lamp. He used to sit in a wicker chair, perpetually reading. In spite of his advanced age, he could still read without glasses.

When Miss Smith knocked on the door my father, who always had an eye for the ladies, let her in. I introduced them and then, after a few pleasantries, she and I went off together.

It was a cold, dark night, and I felt reassured holding her knitted gloved hand. My memory dims then, but next day at school she referred to our trip. It was an endearing episode from my early childhood.

The bomb which I mentioned earlier that fell in Stretton Road came down near to St Martin's Church. I became very friendly with one

of the vicars of that church. He was an interesting man who often, in later years, used to come into my shop to have a talk with me. One day he said they were going to have a fête, and he wanted a banner stretched right across the road with details of the fête on it.

One evening I went to the vicarage, because I was keen to see how he was getting on with the banner. He had been trying to write something on a roll of white ceiling paper, but hadn't got very far with it.

So I said "Leave it to me, and I'll see if I can help you".

I got a roll of linen, and laid it along the aisle of his church. Switching on some lights, I started drawing letters on the material. I was halfway through this task when I heard a laugh and, looking up, saw the vicar.

He said "I never expected to see you on your knees in my church, Bob". It was a fair comment.

On one occasion he bought a Victorian pulpit from a disused church and George, my odd job man, assembled it. It stands there to this day.

The church of St Martin in Morland Road seems, in recent years, to have been neglected. There is a sad atmosphere. In fact, a lady that I knew told me of a curious incident concerning this. She had moved into a house in Morland Road, and on her first Sunday in the area, attended the church.

Afterwards she was accosted by a lady outside who said "We never attend this church". And, I remember someone, either the vicar or one of the parishioners, saying that they had found all the hymn books scattered over the floor. The work of vandals, perhaps, but who can tell.

This vicar tried his best to put new life into the church and asked me to supply a new church board. This I did and, subsequently, decorated it. Being St Martin's, I painted a picture at the top of the board, showing the saint cutting his cloak in half, and giving half to a beggar. I put some gold round it, and the vicar said it reminded him of a Florentine painting.

It is sad when a church loses its heart. I remember a beautiful church board, that must have cost a lot of money, being erected outside St James' Church. Recently the ruins of that magnificent board were propped up against a wall...just a relic.

On the other hand, I don't like to see the way they tidy up churchyards. God's Acre should have headstones about it.

When St James' Church was flourishing, it was at the time I was involved in amateur theatricals. At the dress rehearsal, before the production was staged at one of the theatres, we used to invite old age pensioners to St James' Church hall. There we gave them a full entertainment of our humble efforts, and handed out tea and biscuits in the interval.

Amateur theatricals are great fun, and I was an invaluable member of the company, because I painted the scenery! It was usually laid down on the floor, and I painted it while people were walking over it. One knew that when it was put up, no one would notice the footmarks.

I also painted scenery for my nephew when he was a schoolmaster. It is an institution of most schools to put on a Christmas play, and I remember painting a large scene of Bethlehem, for a production of one of his plays. It completely filled the back of the stage.

My nephew has now left the teaching profession, and is involved in a Home for Aged Horses.

I said to him once, remembering his scholarly achievements "Are you really happy looking after horses?"

He answered most emphatically "I cherish them all". It is good to think some care about these horses, many of which have been abandoned.

He told me that one night he came back to his house and grounds quite late, and found a poor creature tethered to his gate. It was so thin, its body looked like a plate rack. But, with loving care, this horse is now enjoying some of the best days of its life, after having worked so hard previously.

It seems there is far more care given to animals today than ever before. Although, sadly, there is as much cruelty as ever there was. Once, in Ireland, I saw a horse being beaten with a chain. How cruel and callous some people are.

On the other hand, I think most zoos are now fairly enlightened. In the old days they didn't know how to look after animals, but if you must have animals in captivity, I suppose the treatment they receive now in our own zoological gardens is fairly satisfactory.

One of the anecdotes in our family concerns animals. I understand it was related by Gaga, who was Grandmother Peck's mother. She lived to be one hundred and two, and had a brother at Culloden, in 1746. The story referred to one of her ancestors, in the latter part of the eighteenth century.

This individual had a menagerie. In those days the public were very credulous, and the showpiece of this particular menagerie was a creature supposed to be half horse, half cow.

Eventually the menagerie was given up, because the wife of the owner became annoyed at small boys pointing her out, and crying "There goes the half horse, half cow woman!"

One day, when she was a spinster, Gaga's daughter, my grandmother, was discussing the possibilities with a young friend of finding a husband. As they were talking, they saw my future grandfather go by in a gig, with a high stepping horse between the shafts.

Her friend said to her "Look, that's Duke. He's the man you should marry".

She did marry him, and they had a long, happy life together. Duke, short for Marmaduke Horatio, was a glorious name. No doubt the Horatio was after the victor at the Battle of Trafalgar. Horatio Nelson died on HMS Victory in 1805, twenty six years before my grandfather was born.

Eccentric in some ways, grandfather made and lost a lot of money. One of his extraordinary hobbies was the making of ice cream. He had the recipe from the chef of one of the great hotels. Before the days of refrigeration, one bought great blocks of ice, and in the garden of the house where I lived for most of my life were two ice wells. They are now filled with soil, and planted with hydrangeas.

I did make a drawing of my grandfather, but don't know where it is. It is not so good as the drawing Handel Lucas made of my great grandmother, Gaga, which I still possess.

Drawing is, as Ingres said, the probity of art, and drawing has always fascinated me. Whether it is the work of Michaelangelo or our own Augustus John, it is a great discipline for the artist.

Many years ago, on a visit to the Victoria and Albert Museum, I went into the Armoury, and there were students on camp stools

drawing various pieces of armour. It seemed to me many of the drawings looked rather flabby.

I asked one of the draughtsmen, a young man of about twenty and near my own age "What are they doing all this for?"

He replied "There's a small prize offered, for the best drawing of a suit of armour".

"Can anyone go in for it?" I asked the student.

"I suppose so," he answered, whereupon I made enquiries and found this was indeed the case.

Armour has always fascinated me, and full plate armour represents the perfection of the craft. But, like everything, the seeds of decay are in the zenith. No sooner had it reached this standard of excellence, round the time of the Field of the Cloth of Gold in 1520, than the introduction of firearms came about. The complete protection the armour had provided was at risk.

I chose as my subject a suit of armour of the Nuremburg School. The drawing took some time. I was fairly pleased with the result, and submitted it to the Victoria and Albert Museum and, in due course, received notification that I had been awarded a prize. At that time, I was attending life classes at the Croydon School of Art, and when I told Percy Rendell, my master at the Art School, he was very pleased. Immediately he left the class, and went to tell the Principal. I suppose he thought it was a little kudos for his own tuition.

I admired Percy Rendell's own work, and his tuition was always sound. He taught me much.

They were happy days, and in addition there was an amateur dramatic society at the school, and I remember their production of 'Passion, Poison and Petrifaction' by George Bernard Shaw. I played Adolphus, and had to wear an extraordinary evening dress...the jacket was half orange and half black. I painted a self portrait in that peculiar garb, and with the presumption of youth, submitted it to the Royal Academy. I could only find a very wide Victorian frame, of a garish gold colour, to fit it.

Unfortunately it was rejected, but of relevant interest some time afterwards was an article in an art magazine. It was entitled 'Why Pictures are Rejected'.

The author pretended he was in the Selection Room at the Royal Academy. After hearing the Hanging Committee accepting some

and rejecting others, he continued by saying "Here comes a portrait slightly over life size, in a strange garb and an impossible frame". No further comment is necessary!

Of course, when submitting a picture to the Academy, not only must the picture be suitable, but of great importance is the way it is framed. The frames must fit in with the other paintings, and their frames. I suppose it is part of the science of exhibiting.

There was a celebrated Victorian artist named Stacy Marks, who understood all about this. In his young days, after a few rejections, he went round the Academy exhibition with a tape measure, and measured the size of the frames on the Line. Then he took the average of these, and painted pictures according to that average. Afterwards he was successful at the Academy. Whether this was the only reason is uncertain, because he was a fine painter in his own right.

CHAPTER 4

*A tale of 'Old Sussex',
local artists and new friends*

Croydon has had some fine artists. I have already mentioned Handel Lucas. When my father was a student of Lucas, the artist had a studio in Keeley Road. Now no more, a car park stands on the site of the house, but in those days many Croydon artists frequented Lucas' studio.

There was, for instance, Herbert Izant, the still life painter. My father said he was a dilettante, because he didn't need to paint if he didn't want to. Another frequent visitor to the studio was Fitzmarshall. I came across a photograph of one of his paintings in an old Royal Academy catalogue. Not only was he a fine flower painter, but he was also very good at painting dogs. How very Victorian this all sounds, although it seems to be what people want again today.

At this time, that is during the eighties of the last century, my grandfather had a very nice dog. Fitzmarshall painted a picture, and put a portrait of this dog into it.

Then there was Maurice Page, who my father thought was the finest artist Croydon ever produced. Page was principally a landscape painter, and I have seen two or three of his pictures where there are wild fowl flying over moonlit lakes. The paintings are very attractive, but inevitably rather 'Victorian' looking.

Now and again, this artist experimented with different styles. Just before my father's period with Lucas, Page painted a large canvas

called 'Rival Beauties'. It was a painting of an opulent vase of flowers, and at the side was a peacock.

One of the coterie of artists who frequented the Keeley Road studio is reputed to have said "This picture of 'Rival Beauties' has been sent to nearly every important exhibition in the country, and never sold. All it's fit for now is to put your foot through it". A very unkind comment.

Another interesting artist, of a generation or so later, was dear old Evercustus Phipson. He was a topographical artist, and painted many views of old Croydon. The majority of his beautiful pictures are now in the possession of the Croydon Library. From time to time, when there is an exhibition of pictures of old Croydon, a few of the delightful paintings by this artist are exhibited.

I knew him when I was about sixteen. He was a small man who used to shuffle along the pavement with a camp stool under one arm, and a drawing board under the other. In his hands were brushes, and a medicine bottle filled with water.

His work is a wonderful legacy of past buildings in Croydon. Kenneth Hyde, the senior librarian of that time and whom I mentioned earlier, told me that Phipson would shuffle into the Reference Library with his latest work, and somebody there would purchase it. If ever Croydon has an Art Gallery, and this is still talked about, there should be a collection of Phipson's paintings of bygone Croydon on permanent display.

All these artists were, for the most part, members of the Croydon Art Society. Before that it was known as the Surrey Art Circle and, even earlier when first formed, it was the Watteau Art Society.

The Croydon Art Society is still flourishing, but its predecessor once removed, the Watteau Society, goes back to the days of Maurice Page. He wrote an interesting diary which is, I think, in the archives of the Croydon Libraries. I made an enquiry about it once, but only had a casual, unhelpful reply. The diary must contain fascinating details about art in Croydon in the time before the turn of the century.

Speaking of the past, there is an extremely early gateway at the side of the current Parish Church that must date back to a period before the original church which was burnt down about 1865. This church became the subject of a painting which is, I believe, in the possession of the Croydon Advertiser. It is a lurid picture of the flames devouring

this original structure. What a spectacle the actual event must have been.

When the fire occurred, it was a very cold night.

I'm not certain whether it was the sexton or the caretaker who went into a pub on the other side of the road, and said to his cronies already there, "It's a bitter night. I've stoked the furnace up...that'll keep them warm". It did, indeed. It caused the fire.

The night was so cold that the water cocks were all frozen. So, the fire raged unabated. There were apparently many people standing about, all unable to do anything to help. Fire is a wonderful servant, but a dreadful enemy.

Then, Phoenix like, the new church arose. Although it may be criticised as being very Victorian, it has an affection in the minds of most local people.

The pub I mentioned was kept by John Ruskin's aunt. He speaks of it here and there in his writings, including the happiest of his work, 'The Praeteritor'. Near to Croydon is Beddington, which Ruskin also wrote about.

Tom Whittle, the son of Tom Whittle senior - who stood for Handel Lucas' picture 'The Old Sexton' - painted one or two scenes around Beddington, and in Croydon Libraries there is an oval painting by him of Addington Church. In Addington churchyard lies buried Ruskin's father, a wine merchant.

The Whittles seem to have been a curious family. Many years ago I knew a member of the family who was by then very aged. At that time I was very interested in clocks, and went to see him because his clock had stopped. On the walls of his house were early paintings by the youthful Handel Lucas. I believe these paintings were eventually bought by a dealer, and no one knows what happened to them. Coming back to the clock, I set it in motion and was just going to put it right when the old man said:

"Oh, no...that's summer time. We keep it at the Lord's time - an hour back, please."

This shows what an eccentric man he was. He evidently thought the Lord's time was in use before summer time was introduced!

I asked him what he meant by that, and he answered, "My brother disagreed with so called summer time. He was very clever...He also said the earth was flat, and I agree with him".

I tried to point out that if you placed sticks at various distances you wouldn't see the last one, because it would be going down a curve. He didn't seem to understand that explanation.

There was one wonderful theory believed by many of the ancients that the sky at night, studded with stars, was the floor of heaven. They thought the stars were cracks or holes in the floor, which showed light behind.

At the time, when I adjusted the clock for Whittle, I did several clock repairs for some of the dealers in Croydon. I was assisted in this work by a very old clock maker...Old Sussex. Not his real name, but I'll call him that because it's better that way!

He was a watch and clock repairer of the old school, and wasn't interested in the modern method of cleaning watches by using fluids. Each part was cleaned by hand, and meticulously oiled in a way which the modern clock repairer doesn't do.

He could repair a verge watch and an English lever watch, also he could fit a cylinder to a cylinder watch. Few modern repairers would take the trouble to do this, as the majority seem to want only the perfectly straightforward jobs. Before I knew him, Old Sussex had a very successful shop of his own, and his business was successful enough for him to send his two daughters to a good school. Eventually he had two shops, but the manager of the second shop was a rogue, and it never paid. That manager sold the stock, and although he replaced the things he'd sold, he kept the profit.

Whether this was the reason for Old Sussex deciding he'd had enough I don't know, but he sold his two shops and bought a country pub. This turned out to be a disaster. Owning a hostelry was completely out of character - he was not the 'hail fellow, well met' type of person that is necessary to be the landlord of a public house. The business, he said, was completely beyond him. Motor coaches would pull up, and sometimes the bar was so crowded with jostling people - he couldn't possibly serve them all quickly - that many grew impatient, and tried to climb over the bar and help themselves to drinks. He lost a lot of money. The last straw was when the pot man was found to have twelve bottles of whisky under his bed. That's the kind of staff he had. So now, no watch and jewellery business, and no country hostelry.

Just before he bought the public house, he had purchased a small jewellery business near the docks. It must, at one time, have been

a haven for crooks to get rid of some of their stolen goods. When he took over this new business, he found in the drawers behind the counter many broken watch cases, with pieces of gold still attached to them. I believe Old Sussex made a fair amount of money from these pieces of gold, obviously left behind by the previous dubious watchmaker and jeweller!

Like many clock and watch repairers of the old school, he liked to work late at night when everything was still, and he could concentrate without interruption. He once told me that if he could have a bottle of port beside him while working late, this was his idea of bliss. His imbibing, however, seemed to have no ill effect on his work and superb craftsmanship.

The previous owner of the shop, according to Old Sussex, was undoubtedly a 'fence'. From time to time, strange men would come in and enquire about the previous owner. On discovering he was no longer there, they beat a hasty retreat. One man came in with a bale of silk and, being told the business had changed hands, left the material on the counter and hurried out again. I wonder what happened to it.

One touch of drama is associated with this story. Old Sussex was working late one night when the front door bell rang. With some impatience he got up, went to the door, and unbolted it. There was a man standing on the step who said

"There's something in this shop that belongs to me. Can I have it?"

"What do you mean?" Old Sussex asked.

"It's behind the counter" was the reply.

"Where exactly?"

"By the bench."

"All right, you'd better come in. I'll come to the bench with you." The man went behind the counter, and knelt down at the far end where the bench was situated. Then, to Old Sussex's amazement he unscrewed one of the legs of the bench. Taking a large handkerchief from his pocket, he laid it on the floor and tipped the leg upside down. It was hollow, and as he did this, out came a cascade of rings, bracelets and brooches. He then put the four corners of the handkerchief together, stood up, and without a word ran out of the shop. No doubt he was one of the many villains who had carried on illicit dealings with the previous owner.

It was shortly after this that Old Sussex gave the shop up. I believe he thought it was too risky to stay there. That was when he bought the country pub.

Although the jewellery business is an honourable profession, there have been black sheep who have besmirched the name. However, the practices of the shadier members of the fraternity make for fascinating, if somewhat dubious, reading. In fact, all the trade-picture, antique and jewellery dealers - find talking about these men of absorbing interest. An antique dealer that I knew specialised in furniture, and he told me about a woodworker who would take one Chippendale chair, dismember it, and by making copies of the various pieces produce two chairs from the one. Then, there was the silversmith who would buy a can shaped tea pot, remove the spout and handle, and turn it into a tea caddy. In the British Museum is a case of books, the result of the nefarious dealings of an antiquarian book dealer who forged rare books.

And again there was an Italian marble carver who made several busts in an antique style, which were sold as genuine quatrocentro carvings. Even the great Michaelangelo, when he was a young sculptor, made a statue of a fawn in the manner of Pheidias, and after completing it, buried it for a certain period. Eventually he dug it up, and duped the members of the Medici court. There was a man named Bertoldo, a kind of curator to Lorenzo the Magnificant's collection of marble statues. No doubt he was the 'expert' who passed off the Michaelangelo fake as a genuine Grecian antique.

The most classic example of that darker side of the world in antiques is the faking of the Vermeer by Van Megerin. He certainly duped the art world and his masterpiece, if one can call it that, was faking Vermeer's 'The Supper at Emmaes'. A well known museum in Rotterdam paid a vast sum of money for this picture. This, and another which was sold to Goering during the Second World War, shows the gullibility of the so-called experts. Van Megerin used all the materials that a 17th century artist would have employed. He perfected the method of making oil paint hard. However, the powers that be were suspicious of Van Megerin's suddenly improved life style and eventually he was accused of collaborating with the Nazis, and imprisoned. There, in an effort to underline his skills, he started

painting another picture in the Vermeer style, but died before he could complete it.

The public, however, always like to see the experts confounded. During the cause célèbre there was a poll held in Holland, to determine who was the most popular man. And the Dutch, with their typical dry sense of humour, voted for Van Megerin. Of course, the Dutch have always admired craftsmanship, and in its perverted way Van Megerin's first Vermeer fake was an example of just that.

There is an interesting example of the permanence of Dutch craftsmanship. I had sent to me by a London firm, a 17th century Dutch painting on an oak panel, to be restored. It was a typical canal scene with a low horizon and a large sky above, and included a few becalmed vessels. While it was in my possession, another similar subject was sent down from Scotland, also to be restored. The oak panels were exactly the same size, and when laid side by side the horizon line matched perfectly. How extraordinary that they were produced in Holland about 1640 and, despite their many owners and travels, after more than three hundred years they had come together in my studio in Croydon.

These Dutch Masters were, of course, the great inspiration for our own landscape painters. John Constable, in one of his letters, speaks about copying a picture by Ruisdale, a great Dutch artist. The reason he gave for doing this was that he did not want any embarrassment about painting a certain item, and the Dutchman showed him the way to do it. The Norwich School, which had such a profound influence on landscape painting, admitted their debt to these same Dutch masters. In fact, the very last words spoken by John Crome, the founder of the Norwich School, were "Hobbema, Hobbema, how I have loved thee".

Hobbema was the painter of the wonderful 'Avenue at Middelharnis', which is now in the National Gallery in London. Like so many Masters, he was not recognised in his own day. To keep body and soul together he took a job as a customs officer. Strange to think that one day after this change of profession, he opened his paint box and produced that wonderful picture. Not only his swan song, but the greatest picture he ever painted.

What a strange thing fashion in art is. That picture was in the Town Hall in Middleharnis and eventually the City Fathers no doubt thought it slightly old fashioned, because they sold it to this country.

One of our greatest treasures was their loss. Subsequently they realised their mistake, and I believe there is now a copy of it hanging in the Town Hall. We are fortunate that the original came to this country.

The first gallery that was open to the public was not the National, but the Dulwich Collection. On the other hand, the first collection of pictures bequeathed to this country was in a London mansion...100 Pall Mall. In those days it was difficult for art students to study Old Masters. Sometimes they bribed the butler of a great house for a quick glance at the pictures that were hanging on the walls.

The Old Masters then were sacrosanct. Studying them, and a visit to Italy was the usual thing. One must realise that the art of the Classic - the Italian School - has been the source of inspiration since the Renaissance. With the passage of time, their influence has become weaker. Until at the end of the 19th century, the Renaissance influence had become very attenuated. And the more active of the disputers said the Italian School was the lumber room of the Renaissance, and must be swept away. Such thoughts were the precursors of the Modern Movement. Van Gogh, Gauguin and Cezanne were the principal instigators of this Modern Movement. They were the first of the Modernists, but are now called Old Masters in their own right. Time flies, and they have given way to some of the avant garde painters of this generation. Not only in painting, but also in sculpture and architecture, we see great changes, not always for the better.

In painting, perspective is not sacrosanct and, in fact, the Oriental has always laughed at the Westerner's fetish for perspective. We sometimes see a beautiful piece of porcelain, with boats and trees where there should have been the sky. We accept it in oriental art, and we've still got a lot to learn from the Orient. Some modern sculpture shows little interest in anatomy, and modern architecture has little to do with the Doric, Corinthian and Ionic Orders.

There is a grammar, of course, about all things and although in their work writers wisely conform to the rules of grammar, today much of the work seems to be little better than experimentation. I must confess that I like to see some allusion to the Classics, even in modern painting. It is a mark of schooling in writing, and I prefer a similar convention in painting and architecture. When we read Wordsworth's wonderful sonnet 'On Westminster Bridge', and think of the

architectural skyline as it must have appeared to him, the skyline today makes a sorry contrast.

I like to think again of those distant days in Cherry Orchard Road. Looking back to the time of my childhood, I only seem to remember the sunny days.

On the other side of the road from where I lived is a large half timbered pub. When I was a small boy, it was a little beer house decorated with green tiles. The Park Cottages I have already mentioned all had front gardens. Land was cheap then, and where the gardens touched the road, stood small paled fences. It was a pretty sight on a summer morning to see those gardens with their flowers and, on the first of May, the coal carts and builders' carts went by, the horses gaily bedecked with ribbons. At the end of this terrace of cottages stood an opulent Victorian residence, with stone steps that led up to the front door. This house lay back from Park Cottages, and the forecourt which came to the edge of the pavement would be filled, on summer evenings, with children playing. After that, the terrace of houses continued, but now this second row of cottages had all been converted to small shops. The first was kept by a delightful old lady called Mrs Winter, and on their way to school the children would run in there and buy a pennyworth of sweets. This dear old lady would dispense them by wrapping them in a paper screw. Then came another four cottages, and after that a fishmonger's shop. I always went by with some foreboding, because the fishmonger had an awe inspiring military bearing, and a very large moustache.

The small sweet shop next door to this gentleman was kept by his wife and daughter. Then there was Mrs Tyler who had a secondhand clothes shop. She was a large, fat woman and had a son, or possibly an adopted son, who was a dwarf. As children we always called him 'Buttons', because he wore a dark brown monkey jacket and trousers, and the jacket had a row of brass buttons. He was employed by a local dentist to open the door for prospective patients. As the years went by, one realised he was mentally retarded.

After Mrs Tyler's shop, which bore a big notice - 'Gentlemen's Cast Off Clothes Bought and Sold' - came another beer house, The Nag's Head. More cottages, then the school passage, along which the children used to race to school in the morning, fortified by Mrs Winter's sweets.

In those days, a bell would ring calling the children to school. I have not heard that bell for many years. After the school passage was a dentist, the house jutting out on the same level as the cottages. His name was Hagen, and over the road exactly opposite his house, there was a stone mason's yard. Now a block of flats stands on that corner but in those days, the land before the stone mason's house was embellished with a selection of fine statuary. Next there were a few minor shops, and then a forge. Forges were so important in those days of horses, and this one was kept by a blacksmith and his two sons. Here, on a frosty morning, there would be a queue of horses waiting to have their shoes roughened, so that they could contend with the slippery roads. It was all so lovely and simple then. Everybody knew each other. Going down George Street, for example, I would nod at the shop owners. Now, when you walk down the same street you know nobody and nobody knows you... the impersonal attitude of modern life.

Turning out of George Street, when you came to Park Lane, there was no roundabout to facilitate traffic flow. Instead, the human element - a policeman on point duty. He would raise his arm in an imperious way, and the traffic would stop.

Park Lane was quite an exclusive road at that time. The principal fire station stood there although now it is on Duppas Hill. Next to the fire station was the attractive double fronted shop kept by Mr Price, the picture framer. His art gallery was next door. When I went for a walk I would always, as a matter of course, look at Mr Price's pictures. From time to time he had something very beautiful on display. As I've mentioned, the art gallery was the venue for the Croydon Art Society, up to the time when modern development took place. And, no doubt to supplement his income, the gallery was also used on a Saturday night for dances, called hops in those days.

There was a narrow passage next and, on the other side, the surgery of a Dr Cole, whom my mother sometimes visited. I disliked him intensely, and whenever my mother took me to see him he always pushed the handle of a spoon into my mouth, to press my tongue down. On the other side of Park Lane, opposite the surgery, the land dropped down suddenly and there was a picturesque bowling green, framed by rambler roses. About here the early railway lines were situated...the station in those days was in Catherine Street. These must have been placed there in the second half of the 19th century. The many pigeons

that throng the pavement round the present Town Hall are the descendants of the pigeons who fed from the nose bags of the cab horses that stood outside the station.

The railway track was originally laid on the site that is now the Town Hall Gardens. Of course, these are old dim memories, long before our own time.

Before the Fairfield Halls was built, there was a passage that led from Park Hill Recreation Ground to Park Lane, with a bridge over the railway line. And before you arrived at Park Lane there was a meadow with a donkey in it. On Sunday mornings, my sisters and I used to feed it. In the past this must have been a shunting line when the station was in Catherine Street as before they developed the Fairfield Halls site there were still buffers, obviously a relic of a bygone age. In fact, Town Hall Gardens gives an idea of the level of the old railway.

Fairfield Halls and Fairfield Road are named after the old English Fair, held approximately on the site of the Halls. One of the programmes for a concert there some time ago had a picture of the Fair on the cover. I believe the Fair was discontinued when, during a riotous period, a lady fell out of a swing and was killed.

Near where the Fairfield Halls now stand was the attractive bowling green I've mentioned, and also a rifle range.

In Park Lane was a beautiful Georgian house called St Anselm's College. One day during the last war, a bomb fell near to it. The army came to diffuse the bomb, but it then exploded and the vibration was felt as far away as Cherry Orchard Road. It shattered the windows of a shop a few doors lower down from where I lived. I was standing on the doorstep at the time, and the blast blew me off my feet and back into the shop. That same night a V1 or Flying Bomb landed in Milton Road just past Windmill Bridge.

In Leslie Grove, about this time, there was a place of worship - possibly Plymouth Brethren or some similar denomination - and in the evening you could hear them singing their hymns. I don't think there was any instrumental accompaniment. Somebody told me they just blew a whistle before each hymn. They seemed to be quite successful materially, however, and after the war there were always a number of opulent cars outside when they held their meetings. I suppose there are many paths to heaven.

Before and during the war, the houses in Leslie Grove were rather dismal and paint starved. Now, these little terraced dwellings are spick and span, and all freshly painted. Times change.

Cross Road, at the time I'm writing of, was also a long terrace of small dwelling houses, with a few general shops and a shoe repairer. One side of this road is now taken up with a large block of flats, and where the blacksmith's forge was is another block.

Opposite was a public house which is still there...The Horse and Groom, now renamed The Grouse and Claret. Left, back into Cherry Orchard Road more terraced houses and a laundry, where my father had his shirts and stiff collars and cuffs laundered. Just past there lived dear old Pat Everest, the chimney sweep and general dealer. He supplemented his chimney sweep business with small house clearances. And, from his shop, I bought many minor antiques.

He would go past my shop pushing his sweep's barrow with large sacks filled with soot and, occasionally, one or two spoils from his house clearances. Once there was a large gilded picture frame, standing upright in a most incongruous manner on the barrow.

He used to stop opposite my shop, and shout across the road "Got some pitchers today".

And, of course, in a few minutes I would go along to see what spoils there were. It was amazing what he did buy. In those days, minor antiques were almost two a penny.

I remember one lady coming out of his shop with two magnificent glass domes containing linen flowers. They glinted in the morning sun in a fantastic manner. On that particular day she had got to the shop before I did!

Looking back with the benefit of hindsight it is amazing what treasures came out from that little shop. Two things stand out in my mind. One was the frame of a Regency couch with splayed legs...walnut...with elaborate brass inlay. I still wonder why I didn't buy it...he offered it to me for fifteen shillings. Polished and upholstered in Regency material what would it be worth today?

The other was one of those strange early Victorian pianos. Not like the modern upright, but about the height of a door. Many years ago I saw a film of 'Little Women', and in that film was just such a piano. A tall upright with an elaborate fretted front, and crimson rep material at the back of the fret. I think this one Pat Everest had was bought by a

theatrical company and, no doubt, became a prop for them. Fashion is such a fickle jade...at this time Victoriana was looked on with a certain amount of contempt.

Poor old Pat Everest didn't last much longer. He looked a little drawn, and his doctor sent him to hospital to be examined. Pat was a big fat man with a high pitched voice, and told me the consultant said to him "Well, the first thing you must do is to give up drink".

When Pat related this he continued, indignantly, "I told the doctor I had been a life long teetotaller!"

The shop where he lived is now the office of a timber merchant. When I was very young it was an upholsterer's shop.

For some time now, the Victorian age has reached the dignity of a period...no longer is it a source of amusement.

As an old clergyman once said to me, "Never despise the Victorians, my boy".

How right he was. When we did despise them, you could buy paintings by Alma Tadema and Burne Jones for a mere song. In 1930 a picture by Lord Leighton was sold for two hundred pounds. Recently, that same picture changed hands for many thousands. And a Burne Jones painting, that subsequently sold for a phenomenal amount, at its lowest ebb was sold for a matter of hundreds.

In fact, the upsurge of Victorianism has been quite remarkable. Some time ago, when Michael Terle was manager of the Fairfield Halls, I was asked to value the pictures in the Stanley Halls. Stanley was a very enlightened citizen, who bequeathed the Halls to Croydon, and founded the Stanley Technical College. This is still flourishing. He also designed the Halls and Art Gallery. He was a philanthropist as well as a brilliant and remarkable man, and had a great liking for Victorian paintings. He bequeathed his collection of paintings as well as the Art Gallery to Croydon. I was asked by Michael Terle to clean one of the paintings, William Benjamin Leader's large canvas of Mont Saint Michel. Shortly afterwards I was also asked to give an appraisal of the pictures in the Stanley Halls, and there were various features of neglect which I told them about.

The Art Gallery was let out for dances and other functions in the evening, and the occupants of the chairs round the floor were resting their heads on the pictures hanging on the walls. Following my report, the pictures were all raised about one foot, to avoid the visitor's heads

damaging them. Also, I suggested the removal of three attractive water colours, situated behind the hot tea and coffee urns. Subsequently, I was asked to give a valuation of these paintings, for insurance purposes.

At that time, the insurance policy was farcical. One of the principal pictures of the Collection was 'The Wedding Dress' by Gladstone Solomon. That one picture was valued by me more highly than the previous valuation for the whole Collection! But with the present increase in value of all Victorian paintings, my own valuation then is, now, completely out of date.

My connection with the Stanley Halls was due to a disastrous burglary that took place there when many fine paintings were stolen. Shortly after, I noticed in an art magazine photographs of some of these pictures, with a caption 'Waiting for their owner to claim them'. I telephoned the manager of the Stanley Halls, and he went and retrieved them. These pictures were in the possession of the police, who had recovered them. The rest that were stolen, sadly, are still missing, including a beautiful picture by Yeend King of a view on the River Colne. The large Leader I have already mentioned - the one I cleaned - was also stolen and is still missing.

At the side of one of the vestibules of the Fairfield Halls, there was as I mentioned earlier an oil painting of Coleridge Taylor. Croydon looks on Coleridge Taylor, the composer, as one of its most distinguished sons. Due, however, to the fickleness of fashion, his music is under a cloud at the moment. But I find some of his compositions extremely interesting, and I used, occasionally, to play one of his 3-4 Suites, at the end of a talk I sometimes gave on Croydon.

Sometimes when I was speaking to Michael Terle, I would be joined by Nicholas Vilag. A character slightly larger than life I had known him for many years. We used to speak of the great conception of the Fairfield Halls which was the brainchild of Tabener. The latter showed great vision which was queried by certain members of the Council. The Fairfield Halls is, indeed, a great conception-concert hall, theatre, cinema, exhibition centre, cafeteria and restaurant. And, recently, an attractive bar has been added. Altogether, a major centre for social activities in the South of England. It is well nigh impossible to visualise Croydon without this great cultural centre.

CHAPTER 5

The man from Hungary

I first met Nicholas Vilag at one of the meetings of the now defunct Croydon Contemporary Art Group. While in being it was, indeed, very much alive. Through the activities of certain members of the Committee, there was an exhibition of Contemporary Art, held in the old Crown Hotel at the top of Crown Hill. Barclays Bank now stands at the corner where the hotel once flourished.

At the exhibition, which was mounted in collaboration with the Fine Arts Commission, many of the contemporary artists were showing their work. I always remember a beautiful painting by Gwen John - an unpretentious work - that made some of the more bombastic works look empty.

This was one of the more vital parts of the group. It held exhibitions from time to time, criticism of members' work, and sometimes talks by well known art critics. Sadly the group foundered due to the internal bickering of some members and so, something that might have rivalled the Bloomsbury Group or other well known societies, faded away.

On the other hand, the much maligned Croydon Art Society with its long tradition is still going strong. Like many mature societies - one can think of the much bigger Royal Academy - they weather the storm, Despite the reactions of those outside the Academy, it still goes on in its inexorable manner, immune from the criticisms of more advanced societies clamouring at the door of recognition.

When we consider the Royal Academy, from the days of its first President, Sir Joshua Reynolds, and the great names of its principal

members - Gainsborough, Sir Thomas Lawrence and the greatest of them all, Turner - this is a great tradition.

As I said, about this time I was introduced to Nicholas Vilag. He became a very dear friend, and I knew him for many years. He was Hungarian, and a graduate of Budapest University. In the last war he had been a Hussar, and told me he had a horse named Mohammed. Like so many Europeans he was a fine linguist, held a Brussels Gold Medal for photography, and contributed at one time to Picture Post. He came here as a refugee at the time of the Hungarian Revolution, although he maintained connections with Hungary throughout his life.

It was with him that I visited the Hungarian Embassy. Hungary was the most liberal country in the Eastern bloc. From time to time, criticism of the régime was permitted in their press. Nicholas was inclined to be very Left when he first came to this country.

Initially he took a job as a press photographer, but there is no doubt he had a great struggle in the early days of his sojourn in England. Things got so bad that to survive he had to sell, for a mere song, his beloved Rolleiflex camera. However, this critical moment in his life was unexpectedly softened. Next morning there was a letter on his mat containing a cheque for work which he had executed for a commercial company. That saved the day.

At the same time, he started freelance dealing in a minor way. He would occasionally buy a cheap picture - he couldn't buy anything elaborate - and I would restore it for him 'on tick'. After he sold it, he would pay my modest fee. Some of the antics he got up to in order to make a living are now, looking back, rather humorous. One of the funny stories he told me about related to when he was walking one day up Charing Cross Road. Rummaging in a box of books outside one of the bookshops, he picked up a book priced one shilling. He always had an eye for a book, and this was on costume. He entered a stationer's shop, bought a rubber for a penny, and rubbed the price off the fly leaf. Then he took the book back to the Antiquarian Department of the same shop he'd bought it from for one shilling.

The man behind the counter looked at it and said "Oh, there's not much in this...I can only give you a pound for it".

Always impulsive, at a later date he visited a shop in Devonshire Street, and in his usual talkative manner entered into conversation with the lady owner. She told him she was leaving.

He said, immediately, "I think I'll take this shop". Knowing how limited his resources were, this showed great courage.

From that moment the tide of his affairs turned for the better. Looking back I am amazed what a quick learner he was. Before long, he was known to nearly all the print dealers in London, and was a frequent attender at the major sale rooms. He journeyed round the country, and bought extensively. Prints and water colours could be purchased, at that time, quite reasonably.

Just after the war, prints and water colours were the Cinderellas of the art world. And, at the same time, Victorian paintings were looked upon with some contempt. Very soon fashion changed, and eighteenth century water colours became collector's items at fair prices. By this time, Nicholas was established in Devonshire Street.

On the opposite side of the road was the house where Christine Keeler lived, and next door to Nicholas' gallery was a very exclusive little restaurant, run by Peter Langan. I did go into that restaurant with Nicholas...a surprising place, with lovely pictures round the walls. Included among these was a very fine Dame Laura Knight, from her early period.

Nicholas' gallery was a treasure trove of early prints and fair quality paintings, and collectors, dealers and friends frequented his gallery in a fantastic way. The intellectual conversation in that small place was quite amazing...his gallery seemed to be a magnet for so many people. Iris Murdoch, Graham Greene and his brother, the distinguished medico, and George Mikes, a Hungarian writer, were among them. Also, I met Lady Epstein there. One doesn't wish to continue name dropping, but another frequent visitor was Diane Pearson, who wrote the best seller 'Czardos'. I looked forward to visiting his gallery, sometimes twice a week. And, in his modest flat in Croydon, I attended regularly on an average three times a week. When, eventually, he came to the end of his days I was, indeed, sad, because he was one of the friendliest men I ever met.

He also had published a novel about an Hungarian writer, who ghosted his stories through another character. At the time everybody wondered who the author was. Friends who visited the gallery in Devonshire Street were always welcome and he kept a kind of running buffet for their benefit.

There was wine, spirits, and a selection of delicious food. He was most generous in this way. And, in that curious little room at the back of the gallery, sitting at the head of the table with six or eight guests Nicholas, the vegetarian, would ply us with all sorts of meats. The drink and the conversation flowed incessantly. They were very happy days and from time to time Nicholas had evening soirées, and it was amazing the people who came to these gatherings, and enjoyed his hospitality.

Among his guests was Thelwell, the humorous artist who draws all those little girls and fat ponies. I remember seeing a reproduction of one of his pictures, in a pub near the Crystal Palace. It showed a man polishing the floor of the saloon, and coming straight towards him was a fox, pursued by a pack of hounds. One can understand the humour of what the pub floor would be like, after they'd all passed through. And we admire his chubby little ponies with school girls sitting on top of them.

When Nicholas died his fine collection of eighteenth century prints, and all his paintings, should have gone to Sotheby's or Christie's. But the Executors preferred to fritter away that fine collection to a general dealer who came along. Still, I suppose he had a happy time while he was there, and I think he was more interested in the friends he made than in making a profit. He had a coterie of friends who enjoyed his company. They gave him life, and that made him happy.

After his demise, I was speaking to one of his lady friends - a gifted artist and potter - and she said "Yes, we all miss him...he kept us together".

He had an extremely interesting and warm personality, with the gift of making and keeping friends. I have been in his room when he was telephoning some of these people, and asking them if they were coming round that night to see him. He was completely uninhibited in that way. Whereas we might have reservations about cultivating friends, he would search them out.

I remember going to the Fairfield Halls with him one night, and in the interval Nicholas said to me "The pianist is a Hungarian - I must go and meet him".

He wanted me to go with him, but I said "Oh, no, I'd rather not". The pianist was Louis Kentner.

One thing that struck me as rather strange about this brilliant pianist was how low he sat on the piano stool. I've never seen this before or since.

Nicholas, being a Hungarian, was fascinated by the music of the great Liszt. I think he had read much about Liszt's work, and would talk about him and his association with Chopin, and other great pianists of that epoch. I often wonder what Liszt would have done if he had been performing on a modern pianoforte. Liszt, like his friend Chopin endowed the piano with a will and literature of its own. Some say they corrupted the art of Mozart, by this great upsurge of romanticism.

The pianoforte instrument that Chopin and Liszt used was primitive compared with the modern overstrung iron framed version. The efficient touch of the modern piano allows incredible technical feats, that would not have been possible on the instrument Liszt played on. One of the joys of a modern piano is the response of the keys. I have heard it said that the pianos Liszt used were worn out in six months.

The great rival to Liszt on the concert platform was Thalberg. Nowhere near as theatrical a player as Liszt, Thalberg was very reserved...one could almost say aristocratic, in his playing. Nevertheless, the niagra of sounds that Liszt created made him the star performer.

Thalberg produced an interesting composition based on 'Home Sweet Home'. Many years ago, when my father was a student of Handel Lucas, the latter had, as I've mentioned before, a studio in Keeley Road. One of the coterie of his friends who frequented the studio was a fine pianist and organist, named Harry Balfour. My father remembered Balfour talking to Handel Lucas about Thalberg's 'Home Sweet Home', with variations. There was a pianoforte in the studio, and my father was amazed when Balfour sat down at the piano, and began to play part of this work with his gloves on.

Of course, fashions change, so one must remember that at the time that happened, artistic appreciation was quite different. Not only the great Liszt played variations on popular tunes...Paganini did the same with his fantastic variations on the 'Carnival of Venice'. And such was his fervour, it is said that when producing some of his virtuostic fireworks, he half severed two of the fore strings of his violin. Continuing in the same high pitch they snapped, and though the

audience gave a gasp of amazement, Paganini continued playing the same piece of music, using the two remaining strings.

Not only were these two contemporaries great musicians, but they were also great showmen. Liszt would play one of his great feats of technique, and suddenly would sweep the audience with his eyes, and his striking appearance would cause some of the young ladies to faint. And, after one of his concerts, the enthusiastic audience unhitched his horses from the carriage, and they themselves pulled his carriage to the railway station. In our more prosaic age, the concert pianist catches the train, like you and I.

I must admit that Nicholas's enthusiasm at a concert sometimes embarrassed me. He would suddenly start beating time with his hand to the music of the orchestra, not only to my discomfiture but probably to the annoyance of the people sitting nearby. He would start declaiming in Hungarian, German, French or English, about where he'd heard that man before. I would stare at the ceiling. Then, at the interval, he would always buy ice cream and bring back two cartons...one for him, and one for me. All these details combined to make a loveable character.

Before ending this chapter about my friend Nicholas, I must tell of the occasions I went with him to the principal Auction Galleries in London.

Occasionally he would bid for a painting and, sometimes, he was successful. From time to time he submitted some of his treasures to the sale rooms and, again, sometimes he was successful, sometimes not. When his Lots were unsold, he would philosophically shrug his shoulders and say "The luck of the draw".

I frequently saw wonderful treasures in his gallery. I remember a very large piece of embroidery with gold and silver thread, which I believe the Burmese Ambassador wished to buy. But Nicholas loved it so much he never sold it. It was these artefacts that he had that made a visit to his gallery so enjoyable, besides the pleasure of seeing him.

Knowing him was a very enduring episode of my life. And then, one morning Kate, his friend, rang me to say he was in hospital with a heart attack. It seemed he had awakened one morning with pains in his chest, and staggered round to the abode of a distinguished doctor, who was a friend and client. The doctor took him by car to his own

hospital, St Thomas's. Kate rang again, and said she was going to see him on the Sunday. She asked me to go with her, which I did.

I was surprised to see him walking about the ward in a dressing gown. He seemed quite normal, and after he got back into bed we stayed there and talked to him for a short time.

A few days later he telephoned, said he was home and would I go round and see him. He had a modest house in a road near the centre of Croydon, extremely untidy with books, bronzes and tapestries, all around in a kind of jumble. He was sitting in his armchair much the same as he'd done for years, and seemed none the worse for this episode.

I recall him telling me on a previous visit before all this happened that he had been going to a newsagent to buy a paper, and the next thing he remembered was sitting up in bed in hospital. He said they'd given him a thorough examination, and allowed him to go home. We treated it as a little joke and then, a week later, what I have related above occurred.

On seeing him after being in St Thomas's Hospital, he seemed fit again, and we talked as always. I left him quite happy, and I was happy, as though we would brush the whole affair away.

Two or three days later I was telephoned by the wife of a well known Croydon writer. She said she had been round to Nicholas' house, and found him in a very distressed state. She'd telephoned her own doctor, who came, gave Nicholas an injection, then telephoned for an ambulance. This lady must have contacted Kate, because Kate went to the hospital and to the best of my knowledge, stayed with him to the end.

The funeral was attended by very many of his friends and clients. I went in a car with Diane Pearson, the novelist, and Richard Leech, the actor. There were representatives from several of the large galleries in London, and among the crowd of people in the ante room by the Chapel I remember seeing Doctor Hardy - an associate of the gallery - and his wife, and Brian Sewell the art critic.

A few privileged people went back to Kate's house, for the usual wine after such a sad affair.

Resquiat in pace, Nicholas.

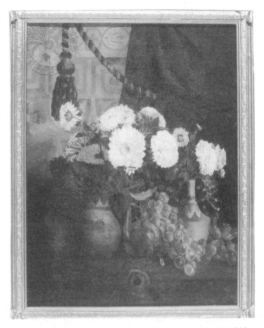

Flowers painted by Robert Dumont Smith, Senior in 1882

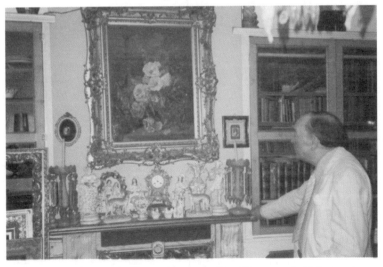

Robert Dumont Smith looking at what was considered by many to be his best work

Winner of First Prize in a competition for the whole of the South of England

A chestnut horse

Robert and two of his sisters

Robert's sister who was known as Dod

Thinking about Morandi

Still life

Suit of armour.
Drawing which won the Farquharson Memorial Prize in 1931

Robert at work in his garden

Robert Dumont Smith with the actor Richard Leech,
author Diane Pearson and another artist, Richard Tearo

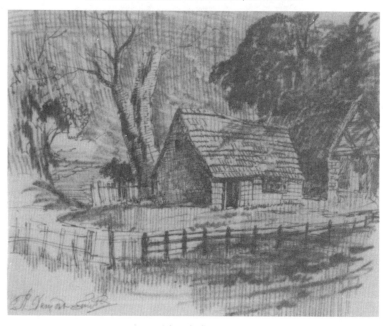

A barn in Surrey

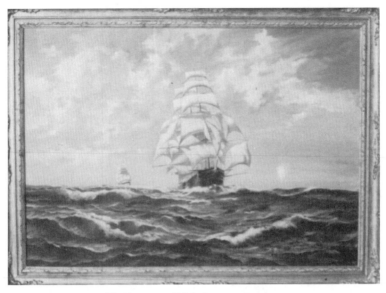

Maritime scene. Original was a watercolour

R. DUMONT SMITH

Messrs. William & Gilbert Foyle
request the pleasure of your company
at the Private View of

AN EXHIBITION OF PAINTINGS BY

R. DUMONT SMITH

on Wednesday, 26th August, 1953

FOYLES ART GALLERY
Trefoile House Charing Cross Road London WC2

*The Exhibition will continue until Saturday, 19th September, 1953.
Daily from 9 a.m.—6 p.m. (including Sats.) Admission free.*

Invitation card for an exhibition at Foyles

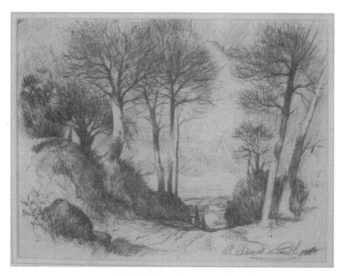

Woldingham Woods, Surrey

Robert with Puck

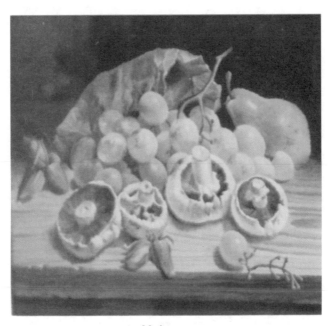

Mushrooms

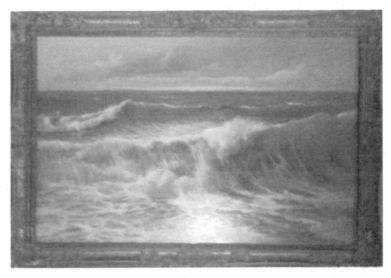

The wave

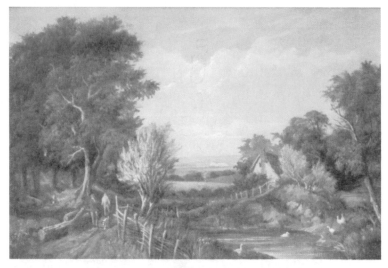

Country scene

Robert in his garden

Croydon Pest House. Painted in 1939
Robert's father also painted this when he was 15, in 1881

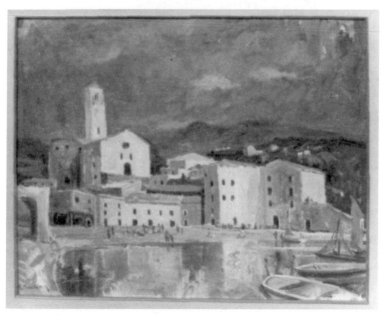

A village in Italy

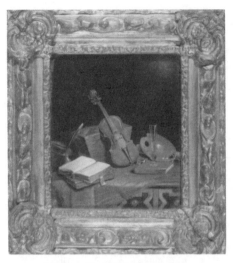

Still life with violin, book and palette

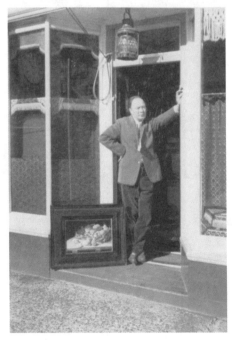

Robert outside his shop with one of his paintings

LIBERTY & CO LTD

REGENT STREET, LONDON, W. 1.

TELEPHONE
REGENT
1234

TELEGRAMS
LIBERTY
LONDON

EXHIBITION OF PAINTINGS
by
Robert Dumont Smith

1.	English Landscape	68 gns
2.	Flower Piece	74 gns
3.	Flower Piece	74 gns
4.	Flower Piece	74 gns
5.	Flower Piece	84 gns
6.	Flower Piece	68 gns
7.	Farm at Dorking	34 gns
8.	The Wave (Abstract)	38 gns
9.	Claud (Portrait)	74 gns
10.	In the Park	42 gns
11.	Boating Pool	27 gns
12.	After Rain	20 gns
13.	A Tall Story	23 gns
14.	Romantic Landscape	34 gns
15.	Victorian Echo	74 gns
16.	Evening Light	18 gns
17.	Still-Life Group	68 gns
18.	Companions (Miniature)	not for sale

PICTURE ROOM November 26th — December 8th 1951

Price list for an exhibition at Liberty & Co.

73

CHAPTER 6

Enduring loves,
Jeffrey Farnol and Fred Webb

My own love of antiques and works of art goes back to the days of my childhood. When I was about thirteen or fourteen, an illness necessitated my staying in bed. I was not ill in myself, but the doctor prescribed cotton wool masks over my face, because I was suffering from erysipelas. Lying in bed was very boring, but the tedium was relieved by a pile of Connoisseur magazines, which were on the table at the side of the bed. With nothing else to read I perused them avidly, and became something of an authority on many aspects of art. Constable's paintings, his friendship with Sir George Beaumont, Turner and his biography by Thornbury which I now see to be what it was...a ridiculous work. However, at the time I read it. There were so many articles in those magazines, and I became quite knowledgeable. Not only about paintings and artists, but also concerning Billingsley, that exquisite painter of porcelain, and his association with Swansea and Nantgarw.

My taste was far more eclectic than the formal art education of today. I admire the paintings of Alma Tadema, and can remember analysing the composition of some of his pictures in a way that few art students would ever consider. One hot summer afternoon, I lay on the bed and studied a coloured illustration of John Sargent's 'Carnation, Lily Lily Rose'. Shortly after, while still confined to bed, I read Whistler's criticism and his feeble remarks. Recalling the brilliant effect of twilight in that picture, and the Chinese lanterns glowing in the light of the

summer evening, I threw the pages with Whistler's futile criticism on the floor in disgust.

The day came when the doctor said I could get up. "Thank goodness!" I said.

Once in circulation again, I found myself fascinated by the subject of art and antiques. My father had an extensive library on these subjects, and what had hitherto been a sealed cabinet was now for me a source of untold fascination and pleasure. The books on these shelves became a vade-mecum of all knowledge that has stood me in good stead all my life. That, of course, is the great wonder and beauty of art.

When I go to the National Gallery or, come to that, any of the great galleries, time stands still. The enduring beauties of art are immune to the passing of time. Going into the Wallace Collection, National Gallery or the Tate Gallery still fills me with the timeless wonder that goes back to my adolescent days. What I find so preposterous is the fickleness of fashion, and a particular prevailing fashion of a certain period. All art scholarship and art studies are very susceptible to this kind of thing. Now, for example, the eclectics are being studied again with renewed interest, and Domenichino, Guido Reni and the Carracci brothers fall into this category. And yet, when I was a student, they were condemned into utter limbo.

In the same way, I remember in those distant days standing in front of a Burne Jones, and the Celtic mysticism of his art cast a spell over me.

I spoke to one of my tutors about this painting, and in a horrified way he exclaimed "Oh, forget all that. You want to study Van Gogh".

Quite recently, 'Laus Veneris' by Burne Jones was sold for a fabulous sum of money, and although Van Gogh is looked upon as a master, and rightly so, the claims of Burne Jones should also be remembered.

Similarly, I do not dismiss Alma Tadema. I remember reading a book by J. B. Manson, sometime director of the Tate Gallery, in which he was condemning many painters, at which we are now looking with a fresh eye.

In his negative approach to Alma Tadema he said "He is even denied the dignity of the auction galleries". I would suggest that any

interested person should study the prices of these artists' work in a Sotheby's or Christie's catalogue.

I once went to Sotheby's gallery in Belgravia to view, when they were selling a collection of Alma Tadema's paintings. The estimated prices, suggested by Sotheby's, made Manson's remarks ludicrous. And, as an artist, I was very impressed by the technical brilliance of Alma Tadema's paintings. Considering some of his adventurous treatments of perspective, such as looking down from a marble terrace to the sea hundreds of feet below, I cannot think of any master who attempted such an effect.

Of course, one must admit he was extremely popular in his own time. These painters were the Elvis Presley and Beatles of their day.

His sumptuous residence built, regardless of cost, in Chelsea had a copper staircase which was quite unique. I understand that Kaiser Wilhelm preferred to stay with Alma Tadema, rather than with his formidable aunt at Windsor.

Talking of Queen Victoria, one realises the awe with which this remarkable monarch was viewed. Her own son seemed to be treated like a boy, right up to her demise.

There is the oft quoted story of Edward with his equerry attending service in the Chapel at Windsor Castle, when the choristers were singing 'Eternal Father'.

Edward turned to his equerry and said "What about my eternal mother!"

Another anecdote about Edward VII concerned the coronation portrait of the King painted by Luke Fildes. It's a fine state portrait, showing Edward in his coronation robes.

And when it was finished, Fildes said to the other Academicians "I have made His Majesty a little taller than he really is".

When the King looked at the portrait, he said to his companion "Mr Fildes obviously thinks I'm a short man!"

There are many interesting anecdotes about prominent people. When Sir Charles Holmes was Director of the National Gallery an influential American had come to this country with his wife, and while he was discussing certain affairs of state, a telephone call came through to Sir Charles - "Perhaps you'll show this important American's wife around the gallery?"

Sir Charles cancelled a previous meeting, and also gave up his lunch to do this.

He thought afterwards that she seemed bored with the whole affair, and when Sir Charles ushered her to the exit, it is reputed she said to her companion "I'm not interested in pictures".

Sir Charles, besides being a brilliant art scholar, was also a capable painter. He innovated a style of industrial landscape that looked in place in an exhibition or public gallery, but was not really suitable as a picture to live with. And that raises the question of much modern art that might look well in an exhibition, but which lacks a social sense.

The Italian School had a Church and wealthy citizens to commission works as altar pieces, and sometimes as large paintings to adorn the walls of villas and palaces. The genius of the Dutch School was to paint pictures for the wealthy burghers, who lived in the tall, narrow houses that flank the canals in Holland. Not for them the very large paintings of the Venetian palaces, but the intimate conversation pictures that looked well in the smaller rooms of their houses, and are just as acceptable in the modern rooms of today.

There is a lesson in this for so many present day young painters who seem to expect some large corporation or municipal gallery to buy their enormous paintings. For some reason, the general public are not very interested in buying their pictures. I suppose, regarding our local artistic activities, the Croydon Art Society goes on flourishing because they stipulate their pictures should all be of a modest size. Certainly, the sale of members' work is very encouraging.

Financially advantageous or not, however, the painting of pictures has always been a great joy to those lucky enough to possess a talent. It does not conform to one strata of society. All classes of people, if they like to paint, do so. I remember dear George, the timber yard foreman.

He was mad about painting and would come into my shop and say "Can I go and look at the pictures?" Then, he would disappear into the picture room and when I went down there - I would have forgotten he was in the room - there he was sitting on a chair, almost as though he were in church.

George was an interesting character and in some way our friendship had something in common with John Constable's friendship

with Dunthorne, the glazier. Constable's parents frowned on this association, but these two men used to walk over the rich landscape of Suffolk, sketching. George was quite a fair amateur painter and occasionally he brought his pictures in for me to pass comment on them.

In his young days he must have experienced poverty. His father was a horse keeper, and died from glanders, that dreadful horse disease that can be transmitted to humans, leaving George, his brothers, sisters and mother almost destitute. Commenting on those days, George said he often went to school in his sister's boots. His mother eked out an impoverished existence by taking the tram to Purley terminus, and then walking miles in all weathers to a house on the way to Coulsdon which, in those days, was all country. Here she did the washing. Hard times, indeed.

George was quite good at mechanical drawing and studied the subject at an evening class. He earned his livelihood as a foreman in the timber yard, and told me he found it useful talking to builders, in order to learn something about plans. One day he brought in a series of mechanical drawings to show me. I was amazed at their neatness but something else amazed me even more.

He must have bought a collection of reproductions of Richard Earlom's engravings of Claude's 'Liber Veritatis'. Not that they were very valuable, but George found the back of these engravings very suitable on which to do his drawings. He was extremely interested in my description of Claude's 'Book of Truth'. And, from that, I went on to talk about Turner's 'Liber Studiorum', which was Turner's literary attempt to rival Claude. Curious, these artists who attempted to do something other than actual painting.

George soaked up knowledge like a sponge. Going to school in his sister's boots, he left at the age of twelve. This recalls Gray's 'Elegy', and the mute inglorious Miltons. Given the right opportunities George could have gone far. He was a loveable character, and completely honest.

I saw Claude's 'Liber Veritatis' drawings after they had been dismembered and mounted separately. The death duties on the Chatsworth Estate were so enormous that the executors agreed with the powers that be, that part of the huge sums involved should be paid by the sale of this book. Prior to this arrangement, the 'Liber Veritatis' was

intact, among the many treasures of Chatsworth. It is now, in its dismembered state, in the British Museum.

Many students and historians have always wished to look at the drawings...the significance of them is that Claude himself made these drawings as small replicas of some of his large paintings. It was a safeguard against the many forgeries that were being painted at that time, and one could verify whether it was a genuine Claude by referring to this book of studies.

Sebastian Bourdon was celebrated or, perhaps, one should say notorious, for his classical landscapes in the Claude style. And there were others equally skilled.

One can easily understand the fascination of Claude's pictures, because he was the first artist to paint landscapes with the sun in front of you. His vision of beauty was quite original. The College of Cardinals were patrons of his, and while the prevailing fashion for classical legends appealed to his patrons, he decked his paintings out with classical illusions. At other times, he would paint a landscape with some relevance to the scriptures. Two I can think of...'The Sermon on the Mount' and the other, one of the treasures of the National Gallery, 'The Embarkation of Saint Ursula'.

The amazing thing about Claude was that he arrived in Italy at the age of twelve to become apprenticed to a pastry cook. His native town of Lorraine was celebrated for its cooks, and despite such humble beginnings, the genius of the man caused him to become one of the greatest landscape painters of all time. I remember seeing two vast landscapes by him exhibited at the Royal Academy, in an exhibition of Old Masters. The luminosity of the paintings was so fantastic, it seemed as though you were looking at two enchanted landscapes through windows. The yearning for far distant shores which is one of the mysteries of humanity, was fulfilled in these masterpieces by this artist.

Our own John Constable said "One could live and die with these visions". And Turner, our greatest artist, said over and over again what he owed to Claude.

One very interesting detail about the fascination Claude had for art lovers...Sir George Beaumont, the eighteenth century connoisseur, possessed a small painting by Claude of 'Tobias and the Angel'. He loved it so much he carried it about with him in his coach

and when this honourable man left all his collection to the nation, he was so distraught at losing his beloved Claude, that he asked whether he could have it back during his lifetime. His request was accepted, and Sir George died a happy man.

One of my favourite books, ideal for the bedside, is 'Memoirs on the Life of John Constable' by Leslie. In this delightful book we read of the happy association of John Constable with Sir George Beaumont.

Constable, obviously remembering Turner's 'Liber Studiorum', had the idea that he would produce something similar. His thoughts ran to another publication called 'The English Landscape'. To illustrate this work he had employed the mezzotint engraver David Lucas. For this proposed book, Lucas was to produce mezzotint engravings of some of Constable's paintings. The book was dogged by Constable's criticism of the engravings made by Lucas for the book. I have seen some of these mezzotints after Constable's paintings, and the velvet-like bloom quality was truly remarkable. There are several letters extant, describing Constable's criticism of Lucas' work.

Briefly, a few technical details may be of interest, concerning a mezzotint. The surface of the plate is covered with a burr, using a tool called a rocker. The result is the plate or sheet looks like a piece of emery paper, and on that roughened surface various thicknesses of the subject are scraped away. Finally, where there are the highlights, such as the light of a cloud, it is necessary to scrape down to the polished surface of the plate. This means that the ink used for the print is darkest where the burr is thickest, and there is no ink at all where the plate has been polished for the highlight. It is, indeed, a very very difficult process. Poor Lucas was one of the last exponents of this difficult art, but he lived long enough to see his beautiful work superseded by modern methods of reproduction. Not wanted any more, this great artist died in the workhouse.

There is no doubt that mezzotint engraving was an art form in its own right. And the reproductions of the paintings of Reynolds, Romney and Gainsborough resulted in some of the most beautiful prints ever produced.

When Sir Edwin Lutyens was President of the Royal Academy, I was fortunate enough to exhibit there. On Private View day, the great Sir Edwin was with two other Royal Academicians...no

doubt talking shop! As I went by, he saw me and smiled. But, I was so shy, I pretended I hadn't seen him.

When exhibiting at the Royal Academy, you are issued with what is called a varnishing ticket. In the old days, many artists did varnish their pictures on that day. Few artists varnish their work on this day now but, as I said earlier, at that time it was the usual thing. Today it is a day when artists meet other artists, look to see where their pictures are hanging on the walls, and also whether their names are correctly spelt in the catalogue.

In my early twenties, when I had my first Academy exhibit, I found myself talking with other artists, some famous, some as obscure as I was. I remember James Quinn, who was looking at his portrait of Queen Elizabeth, now the Queen Mother.

I was staring at the picture while he was standing at the side of me, and then he said "What do you think of it?"

Here was I, a nonentity, being asked my opinion by the celebrated Scottish painter who had been commissioned by royalty to paint this portrait.

Secretly I thought there were better portraits of Her Majesty, but I nodded and said "Very good".

He said to me "I think the paint has dried in...the picture looks very flat and dead".

And, with the temerity of youth I replied "Why not give it a coat of retouching varnish?"

He took a bottle of retouching varnish out of a box, and just skimmed over the face of Her Majesty. Of course, he should have gone all over the portrait, because on Private View day when I looked at it again, the surface of his picture was very varied. Some parts were shiny and others were dead. So much for the young artist's advice to a celebrated master.

On the same morning of the Varnishing Day of which I've been speaking, I had a few words with Meredith Frampton. A charming man, he was exhibiting a large still life picture of a classical urn and a classical head. Beautifully painted, it is now in the room frequented by the Friends of the Royal Academy. Just before his death the Tate Gallery honoured Frampton with an exhibition of his paintings. A pleasant change from some of the more avant garde exhibitions mounted at the Tate.

Another brilliant portrait painted by Frampton was of Sir Edwin Lutyens, when he was President of the Royal Academy. In Frampton's portrait, Sir Edwin is sitting smoking one of his small concert pipes, and on the table beside him is a row of dead matches. I remember that detail so clearly. As I have already mentioned, he always laid the matches in a neat row on the drawing table in front of him.

I remember also, on one occasion, Sir Edwin said to me "Could you go to the Royal Academy, and touch up the tips of the hands on the clock over the doorway. Some of the Academicians have difficulty seeing them, and I think it would be a good idea if they were made a little clearer".

I went to the Royal Academy with my box of paints, and was ushered into the sancto sanctorum...a beautiful room with fine portraits on the walls. There was a long table flanked by mahogany chairs, and as I was looking at the clock high up over the door, Sir Charles Lamb, the then Secretary of the Academy, came into the room.

After he had greeted me I said "I'm supposed to be touching up the tips of the hands of the clock over the door".

Sir Charles said "I'm sure that will be very useful", and as I climbed up the steps to do the job, he very kindly held the steps for me.

From time to time, other notable people have swum into my ken. On one occasion I went with a friend of mine into the country. He knew Jeffrey Farnol, the author, and asked me whether I would like to meet him. I had just read 'The Broad Highway', and 'The Amateur Gentleman' and told my friend that I liked 'The Broad Highway' very much. Here and there, in the book, it seemed to me one could trace the influence of George Borrow's 'Lavengro'.

Farnol's book 'The Broad Highway' was published just at the right moment. Immediately prior to the First World War there was a fashion for costume stories and costume paintings. Artists like Seymour Lucas and Marcus Stone seemed to be on everybody's walls, and this nostalgic looking back to a kind of Regency England fitted in exactly with Jeffrey Farnol's style of writing. I must admit that my first sighting of Farnol was something of a disappointment. I expected to see an elegant man something like a Regency buck. Instead, here was a stocky little figure in plus fours and stockinged feet, standing astride a hillock flying a kite.

My friend went up to the great writer, who was absorbed in keeping the kite flying high, and said "May I introduce my friend Dumont Smith".

Jeffrey Farnol gave a broad smile, shook hands, and said "How do you do", and immediately went back to his kite flying.

All this took place in a kind of blue twilight, and suddenly Farnol cried "Oh, I've had enough of this...let's go into the cottage".

The cottage was a very primitive affair, and the only light a paraffin lamp in the middle of the table. There was a young lady who acted as hostess, and we drank ale, and talked and talked.

Subsequent to our visit my friend said "I prefer Farnol's talk to his writing. I always say to him...why don't you write like you talk?"

We had a jolly good clack, and at about two thirty in the morning Farnol said, "Let's go and pick and some mushrooms".

It was so dark you could see nothing, but every now and again the white disc of a mushroom appeared through the gloom. We had to stoop down in the meadow to see them. I picked a large handkerchief full of these delicacies, and then in the darkness I could hear the voices of my friend, Farnol and his female companion.

They were invisible, but I could hear their laughter, then Farnol's voice said "Let's go back now...it's late". So, we returned to the cottage with our spoils.

We put our collection on the kitchen table. The girl gathered them up, and then at about three o'clock, or maybe a little later, we ate mushrooms and bacon. As the dawn chorus was heard, and the trees began to take shape, my friend and I left this enchanted place, and returned to civilisation.

'The Broad Highway' and 'The Amateur Gentleman' were Farnol's two best books. Those that followed were echoes of these two works, and filled with the same mannerisms.

It had been a lovely interlude, and I thanked my friend for allowing me to meet this engaging writer.

His amanuensis was Captain Chandler who, I believe, died through giving a transfusion of blood for a friend that went sadly wrong.

One hobby of Farnol's was collecting historical weapons. And, in the same way that John Ruskin mutilated early illuminated manuscripts by transferring initials from one manuscript to another -

possibly Ruskin's most pernicious activity - so Farnol removed the decorated hilt from one sword and attached it to another blade. By doing this, of course, he confused the periods. You can see the same fault in some suits of armour, when they come up for sale. Like Gothic architecture, armour can be assessed very accurately to its period.

Another of my literary friends was Fred Webb. A professional journalist with a skilled hand for poems, he was a gentle soul with a robust taste in poetry. He wrote extensively on old London, and at the outbreak of the last war wrote a poem entitled 'The Lion Road', which was published in the Poetry Society Journal. A robust poem, it could have been by Henry Newbolt for its sentiment and was, I suppose, this quiet man's contribution to the opening tragedy of war. His protest against the obscenities of the Nazi régime.

I remember him well. He first drew my attention to Le Sueur's equestrian statue of Charles I...the finest equestrian statue in the country. One of the interesting details Webb told me about it was that during the Cromwellian interregnum, the statue was sold to a scrap metal dealer to be melted down. The scrap dealer must have had some secret admiration for works of art because, despite the fact he was supposed to have melted it down, instead he boarded it up. When Charles II came back to England in the Restoration, lo and behold the statue came to light in all its glory, and once again the statue is one of the sights of the capital.

Not far from the equestrian statue of Charles I, and across Trafalgar Square, is the National Gallery, and one of the other facts of which Webb informed me was that the imposing portico of Corinthian columns, the columns that support the pediment of the Gallery, were originally features of Carlton House Terrace. When Joan and I go to the Royal Portrait Society Exhibition, I think of the salvaging of these Corinthian columns, and the way they now adorn the portico of the National Gallery.

On another occasion, Webb explained to me the niceties of the sonnet form. There was a book of poems published of his work, and then I lost touch with him for a little while.

Some time later, I saw him again. He seemed strangely frail, and I asked him what was the matter.

He answered "It perplexes me when you try to do some good turn, and you receive a rebuff."

84

I asked him what he meant.

"Well, this terribly cold weather I was so sorry for the birds that I took a plateful of crumbs out of the back door to feed my feathered friends, slipped on the icy pavement and hit my head on the ground when I fell". And, in his querulous voice, he added "Isn't it sad...you try to do a good turn, and this happens".

I said I was very sorry. The next time I saw him was about a fortnight later, in Lower Addiscombe Road in Croydon.

I said "Hello Fred".

He looked at me with a puzzled expression, then said slowly "I remember who you are, but can't think of your name".

I repeated one or two inanities, squeezed his hand and walked away. I looked round once more and he was still standing in the same place, gazing with a lost expression at my receding figure.

I never saw him again.

Thinking once more about the Royal Portrait Society Exhibition, portrait painting seems to be suspect today. It is nice to think the traditions are being preserved by this Society.

There are very few portraits in the Royal Academy Exhibitions. The days of Orpen and Sargent and the greatness of their work seems to have passed.

I think it was Delacroix, the great French painter, when he came up against the early photographs, who said "The art of portrait painting is dead". Of course, he has been proved wrong because the two artists I have just mentioned were living long after he made his remark.

There is an interesting fact about the early days of photography. When the daguerrotype, a method of early photography, came into being, Turner was fascinated by the idea. He is reputed to have made several visits to a photographic studio. I do not believe, however, that we have ever traced an early photograph of Turner. There are, of course, sketch portraits produced by fellow artists in existence. I can think of one drawing of Turner that shows him browsing through Old Master drawings at the British Museum. And there is a small painting by one Parrot, of Turner touching up his pictures on Varnishing Day at the Royal Academy.

Turner and these Varnishing Days were a source of great fascination to the other artists. He was in the habit of submitting his usual large landscapes on this particular day.

Arriving at the Academy in the early morning, dressed in shabby black clothes and with a stove pipe black hat on his head, he would stand in front of his large canvas where there was a suggestion of a picture, and the genius would begin to work, turning the chaos into the cosmos of creation. This never failed to fascinate his fellow Royal Academicians. They would stand round in a half circle in silence, while the great man worked on his picture, completely oblivious of those watching. When he'd finished what he was doing, he would pack up his paints and brushes and, without saying a word or looking right or left, would shuffle from the room. The half circle of artists would also quietly disperse. They realised they had something very special in James Mallord William Turner.

Turner looked more like a farmer than an artist, with a rubicund face and short stocky figure, invariably dressed in black.

As he walked down the street, small boys would shout after him "Old black birdee", much to his annoyance.

It wasn't, however, only Turner's art that made him successful. He owned a public house which was evidently a great success, and it is said he invested in government stock. And, going back to his childhood, when money was very scarce, it bred in him a love of money. He knew the value of his paintings to the last pound. We do know that with the days of his success he bought another house in Queen Anne's Gate in London, and turned one of the very large rooms into a gallery to show his own paintings. To decorate this large room, he bought as a job lot the drapery used at the coronation of Queen Victoria. I believe it was red in colour and, no doubt, when hung round the walls of the room with his large paintings in their gold frames displayed against it, the effect must have been impressive.

At this time his aged father had turned into a general factotum to his illustrious son. He would prime the canvases for him and take visitors round the gallery, pointing out the pictures and then holding out his hand for a gratuity. There was a deep affection between the old man and his son. Turner's mother lost her reason and he never spoke about her, but he always referred to his father with deep affection.

And so the years went by. He designed and built a house near the Thames called, I believe, Salem Cottage. After the demise of his father, he became something of a recluse. Towards the end of his days, his fellow Royal Academicians realised he was weakening and, at this time, he had taken up his abode at 119 Cheyne Row. Looked after by a Mrs Booth, the time came when he took to his bed. The weather was cold and grey, and he was heard to complain about the absence of sun. He muttered that the sun was God.

They found him dead on the floor of his bed chamber, and it is thought that he had wanted to reach the window to look out. When they found him, the room was filled with sunshine.

So passed the greatest artist this country has ever produced.

Of course, the nation is now attempting to do Turner proud. With his death the Establishment were somewhat bewildered to find this great artist dead in such a humble abode. The body was removed from Mrs Booth's, and taken to lie in state in his own picture gallery. There is a painting by Hart, showing Turner lying in state.

To digress for a moment. This man Hart was very much like the Duke of Wellington in appearance, and he constantly told his friends and associates how much like the Duke he was.

Eventually, this story reached the ears of the Iron Duke, and Wellington commented "That's funny...I have never been mistaken for Mr Hart".

Unlike today, when a modern artist goes to his resting place with hardly a mention, Turner had the honour of a state funeral and was laid to rest in St Paul's Cathedral, besides his peers Sir Joshua Reynolds and other great artists. Today, this sort of homage and adulation is more likely to be given to pop singers!

We come back to an interesting discussion about the permanence of painting. Turner was not cavalier in the way he painted his masterpieces. He would sometimes mix oil painting with water colour painting to get an effect.

Ruskin, condemning the way Turner painted, said "Nobody can see a Turner in all its glory a month after it is painted". If we remember that, what would he think of Turner today, two hundred years after the pictures were painted.

With my love of antiques and paintings, I was always on the lookout for pictures and works of art that I could buy cheaply. I have

already spoken about the treasures I bought from Pat, the chimney sweep. I had another favourite venue. On Saturday mornings I would go down to Surrey Street, a well known market in Croydon. This market not only sold fruit and groceries, but there were two or three stalls where one could buy oddments, books and pictures. I looked forward to Saturday mornings for my adventures among these treasures. The stall at the top of Surrey Street near Scarbrook Road was devoted to all manner of small oddments.

In my early teens, I was a keen collector of coins. My pride and joy then were some two penny pieces of the George III period. They are known as cartwheels...great thick copper coins...but as a boy I loved them. Goodness knows how people put them in their pockets.

I remember on one occasion running through the heterogeneous stock of this man's stall in Surrey Street, and seeing some coins which I thought I would add to my collection.

With some trepidation I held the box up in my hand, and said to the stall holder "How much is this box of coins?"

Without troubling to look at them he said "Oh, I don't know...give us a shilling for the lot".

It was one of the luckiest finds any boy could hope for. Among all the dingy copper coins, two stood out. One was glinting like the sun, and the other like the subdued light of the moon. The silver coin was a Hungarian thaler, which I sold for five pounds. The gold coin...I forget what it was...I took into a shop and sold it for eight pounds. And, I daresay the people who bought it were being very sharp.

The money from these two coins supplied me with sweets and toffees for many weeks!

Near the steps that lead out of the top end of Surrey Street was a bookstall. I don't think the owner of the stall knew much about books. I picked up among his usual lot of rubbish a first edition of 'Little Dorrit'. I liked this book so much I kept it for many years, and have only recently sold it. Occasionally, among the indescribable jumble of books there were one or two treasures. One day, peeping out of the muddle, there was a beautiful model of Giotto's 'Campanile in Florence'. I picked it up with some veneration.

It was perfect, and I have thought many times of Ruskin's description - "That supreme height of mountain alabaster chased like a

sea shell, coloured like a morning cloud". I liked it so much that I kept it until sadly it was stolen.

At the side of the stall was a beautiful model of the Duomo. But, alas, I had no more money to spend. I wish I knew where it was now, because I would have liked to buy it as a pendant to the Campanile. Santa Maria del fiore, with the dome by Brunelleschi. One of Sir Frederick Leighton's early paintings was of the Death of Brunelleschi and it showed the great architect lying on his bed, and through the window could be seen his masterpiece...the Duomo.

Looking round this room, where I often paint, there are many treasures that were then no more than inconsequential trifles. The passage of time has made them scarce and, as a result, the prices have rocketed. Of course, I was always lucky to have been able to restore them to something approaching their original glory.

One of my cherished possessions is a large painting of the Thames, with Lambeth Palace in the centre of the picture. It is a masterpiece of luminosity. I used to think it could be by Clarkson Stanfield but some people, including my late sister, thought it might be an early Turner. It has also been suggested Koek Koek might have painted it and I must admit that on one of the flags on one of the masts of a ship there are two Ks, but recently Sotheby's attributed this painting to Caleb Robert Stanley (1795-1868). The story of the picture is as follows.

I had been a friend for many years of a clergyman. Father Gracey was a charming man of the old school. A graduate of Oxford...I never asked him what college but imagine it was Exeter...he was now reduced to living in a bed sitting room in an Edwardian house in Croydon.

Many times I climbed up a flight of stairs to talk to him, and remember once saying "However do you climb all those stairs every day?"

He answered "I think those stairs keep me fit".

He had an old sepia photograph on the wall of himself and his two brothers...all Oxford graduates. As a young man he must have lived in a far more important residence than he now occupied. On the mantelshelf there were a pair of silver candlesticks, and a few other things that might have been silver, but here and there a pink glow suggested Sheffield Plate. One of the things I admired in this small

room was an eighteenth century water colour, by or of the school of John Robert Cousins. We discussed the beauty of the painting, and he seemed delighted at my interest.

After I had extolled its merits he said, quite casually, "There's a large painting in store, of the Thames. It's in a Depository at Chiswick. It's been there for many years...I shall never retrieve it". He looked round the room, and I could understand there would be no room to hang it on the small walls.

"Would you be interested in it?" he asked.

"I'd love to look at it."

"I'll write a note, and you can go and see it. It might be too far gone for you to buy. It's over thirty years since I've looked at it."

"Never mind" I said. "I'll be pleased to go and see it".

He went to his desk and wrote a short note, giving me permission to look at the work. Then, rummaging through a book of addresses, he said "You'd better telephone them, so that they will know when to expect you".

On the following Wednesday, I made the journey. The warehouse man was expecting me, and we went through corridor after corridor, and room after room of furniture, pictures and bric-à-brac. They all looked sad and neglected. Unhappy relics of lost homes and lost owners. Eventually we came to a small room at the end of one corridor. It was crowded with large oil paintings in various stages of neglect, all lit by a tiny window covered with cobwebs.

Grunting, the man heaved two or three large paintings to one side, and exposed the picture I'd come to look at. It was in a deplorable state, with the corners of the large gold frame smashed, and the plaster lying on the floor. The oil painting itself had an amber coloured film over it, and a great protuberance in the top right hand corner where another frame had been pressed against it, no doubt, for many years.

I said to the man "What a state it's in. It looks as though it's too far gone".

"I'll tell you this", he answered. "Three men have been to see it, and all have refused it."

Looking at the painting, I thought I also should have to refuse it, but then thought of my clergyman friend, and that he would be glad to sell it. So, I said to the warehouse man, "I'll let you know", and walked out.

When I came home, I suggested a price which I thought was quite generous, considering the state it was in.

Without hesitation Father Gracey said "Oh, that's all right, you can have it".

A couple of days later a large pantechnicon drew up outside my shop, and two men carried the picture in. As they placed it on the floor, another piece of the frame fell off.

As the lorry moved away, I looked at the ruined painting and frame, and wondered whether I'd made a mistake in buying it.

I managed to stagger down the stairs with it, and my sister said "You look very worried".

It was a lovely sunny day, and I took the painting into the garden, removed it from its frame, and considered the business of what I could do with it.

The first thing was to flatten the protuberance which I have just mentioned. I did this by damping the back of the picture. This was fairly successful, and with a second application of a slightly damp rag the painting was completely flat again. Then came the job of removing the discoloured varnish. Luckily, it seemed to have been varnished with mastic varnish. Some of the Old Masters of one hundred or more years ago were fond of using copal varnish with a little boiled oil included. They called it gallery varnish, and boasted it never 'bloomed'. Fortunately, the picture had escaped that treatment, and the mastic varnish removed fairly easily. On closer examination, one could see the stretch marks from the wooden stretchers that held the canvas. This necessitated relining the picture...the original canvas was rather thin. All this took some time and, meanwhile, I realised the frame was too far gone to preserve. So, I ordered a new frame.

This had to be made, as the picture was an unusual size. When the new frame arrived in all its glory, the picture was ready for its final varnishing and so, instead of a painting that was ripe for destruction, the world was a little better for the preservation of a beautiful picture. It has a lovely limpid sky, and makes one think of Wordsworth's poem 'On Westminster Bridge'. For many years it hung on the wall of my living room, and was a source of great pleasure.

Another happy 'buy' was a large painting in the style of Claude. I had no illusions...I knew it wasn't a genuine Claude, although the landscape was very good. But the figures we associate with

Claude's work are different from those in this picture. These figures suggest that my painting is a Dutch copy of a Claude. Although Claude's figures are somewhat badly drawn, they fit his style of landscape perfectly. The figures in my painting are rather plebeian.

Shortly after I purchased it, I came across a mezzotint after Claude by Richard Earlom of the same subject, which means to say the original painting by Claude was engraved by Richard Earlom. I have the mezzotint by me now. The painting is a large one of a river with, at the side, the usual typical large trees that Claude loved to paint. Here again it was a labour of love to restore it. I cleaned and varnished the picture, and extravagantly bought a new frame. It used to hang on the wall by the side of my bed, lit by a picture light, and I would switch the light on when I went to bed. Sometimes in the still watches of the night when sleep would not come, I would switch the light on again and admire the painting. These are a few of the lares and penates that surrounded me. I was very lucky with these treasures. They are all palliatives to life.

CHAPTER 7

Friends of the family, lectures and an illness

As we go through life each episode adds to the story, and each period follows the previous one, with ever increasing rapidity. When we are young and all life is before us, it seems to stretch to infinity.

I can remember sitting at the table watching my mother doing some needlework. Her mother had instructed her in the art, and she in turn instilled the necessity of this 'house-wifely' duty into my four sisters. Many a time have I sat beside her watching her ply her needle, or sometimes using a sewing machine, with equal efficiency. It wasn't so much watching her doing the work, but an excuse to talk to her. At times confidences were exchanged as I looked, in a mechanical sort of way at what she was doing, and thought of what we were talking about.

She told me of her early school days, and of her first meeting with my father. It saddens me to say it, but I don't believe they were really happy together. Nevertheless, my father honoured his obligations and helped bring up my four sisters and myself. Before my sisters were born, mother had had a baby boy, who died of bronchitis when he was eighteen months old. I think he was the great love of my mother's life, and as the years went by she would refer to him in very affectionate terms.

And, constantly, with the hindsight of a woman who had brought up five children, she would say when speaking of this small child "If I'd known then what I know now, we would not have lost him".

But she was married at seventeen...and in those days what could a girl so young know about a baby?

She was a good nurse to my sisters and me when we were ill. Sometimes, on those occasions, I think she was reliving the loss of her first child, and the care she bestowed on us may have been what she had been unable to do before. Looking after her brood became the paramount interest in her life. Her affection for my father waned, and love was concentrated on us, her children. As their partnership weakened, my father obtained his favours elsewhere.

As a young man he had moved in rather an artistic and flamboyant set, quite unlike the narrow confines of my mother's upbringing. I loved them both, but the pull of one against the other was rather difficult for me.

I once saw my father standing on the doorstep in a shower of rain waiting to go up the road, but looking at the rain clouds above.

A young lady went by with her umbrella up and my father said "Oh, just a minute, my dear, may I come under your umbrella?" And they went up the road as though they had known each other for years, arm in arm and laughing. Now, however, all these memories are shrouded in the mists of time. His generation and all the people of that age have gone...only shadows remain.

Rumours of his behaviour lived on into my early days, and there were many elderly ladies who spoke in a disparaging way of things that had happened. But, I think they were the jealous ones. Others, who one could still see had been beautiful, would talk of their early life and speak of him in a tender, reminiscing manner. It was they, I assume, who had bestowed their favours on him. I can see him now, going for a stroll on a Sunday morning, with his patent shoes and his spats - he always liked spats. Striped trousers and a black velvet jacket with a bow tie, a little larger than was really necessary, and a silver knobbed walking stick. Usually, he had a cigar in his mouth, and a velour hat to complete the ensemble. Despite his adversities, he was always romantically happy.

As far as art is concerned, he lived in the past. His interest lay in Frederick Leighton, Poynter and Alma Tadema, with a special interest in the works of Benjamin William Leader. One of his particular favourites was the picture which had made Leader famous. It was called 'And in the evening there shall be light'...an artistic metaphor of

the biblical text. It was a great sunset over a rain-drenched, ploughed field, and the luminous glow was reflected in the rain-filled furrows. At the side of the picture, silhouetted against the sky, was the tower of a church surrounded by God's Acre.

I have seen a reproduction of the picture. I may not have been as emotionally struck with it as my father in his younger days, but I cannot agree with Whistler's carping remark - "Rather a silly sunset". An example of this artist's somewhat acid comments.

There was a picture by Leader in the Birmingham Art Gallery...'February Fill Dyke'. Kenneth Clark mentions it in his book 'Landscape into Art'. Leader had a long life...he was born in Worcester, and spent his time painting views of the surrounding country, and scenes in Wales round the Capel Curig area.

I like that period and find the Royal Academy exhibitions of that time very satisfying.

One of my schoolboy fancies which still holds was John Singer Sargent's 'Carnation Lily Lily Rose'...that lovely picture of summer twilight where young girls are lighting Chinese lanterns, in the twilight of an English garden. The picture was started when Sargent was staying with a coterie of other artists, enjoying the halcyon days of the English scene before the First World War. Playing tennis and croquet in the garden, and at the same time painting this masterpiece. As soon as the twilight was apparent, they would stop their games, and allow Sargent to paint during this enchanted moment in time. Naturally, time for painting was brief, and as it went by and the masterpiece was still in progress, the season changed. Now paper roses had to be suspended from the trees, and the little girls forming the subject of the picture, had to have extra warm clothing under their pinafores. Eventually the lovely painting was completed, and it is now one of the glories of the Tate Gallery.

This style of art lasted until the beginning of the last war...after that, artists seemed to spend so much time trying to be different. It seems that pictures today must be original at all costs, whereas for centuries there has been a gradual progress. I find that very apparent in the portraits at Oxford and Cambridge. Both these seats of learning have fine portraits of the past sons of various colleges, and the generations of their sons show a gradual evolution. And then, suddenly, there was an abrupt change with the onslaught of so-called modernity. Modern

portraits stand out against this heritage in rather an alarming way. My old friend Father Gracey noticed that when we were talking about the subject.

The last time I saw him, he told me with a chuckle that he sat down on a bench in the grounds of his own college, and one of the proctors came up to him and asked whether he had any reason to be sitting there. The seat was sacrosanct to past members of the college. He told the man he had been an undergraduate there sixty years ago.

As I left him for what proved to be the last time, he presented me with three volumes of Coleridge's 'Litteria Biographica'. I was looking at them that afternoon, and they are now among my treasured possessions, in memory of a fine man. I always regret not being able to buy the fine water colour in his room, and often wonder where this picture might have gone. I also wonder what became of the candlesticks I mentioned in the previous chapter.

Shortly after this I became a lecturer for the Inner London Education Authority on Art and Antiques. When I was summoned to County Hall for an interview, the time on the form was so scribbled that when I arrived nobody was there. I complained about the illegibility of the hand writing, but with the arrogance of ignorance they said they thought it was quite plain for anyone to see. A second appointment was arranged, and this time I had a pleasant interview with a panel of four gentlemen. Two of them seemed to know what they were talking about...the other two didn't!

I thought the architectural conception of County Hall was very good, occupying an important site and a fine conception of civic architecture. It may not have been a classical conception like Wren, but certainly much better than the majority of the buildings they are now erecting in London, and which spoil the skyline. The architects seem to have completely forgotten the orders of their profession, but who are we to complain?

The periods I spent lecturing at Penge and Dulwich were very happy times When I attended lectures at the Courtauld Institute, some of the lecturers were precociously clever, but few of them had any idea of imparting enthusiasm for the subject. Some - and they shall remain nameless - mumbled their words in an exasperating manner. Few could compete in delivery and erudition with Lord Clark. He was good.

One of Clark's more recent publications was 'Ruskin Today', a fine book containing extracts from the voluminous writings of Ruskin. I found Ruskin's travel writings extremely fascinating, and some of the descriptions in these may have been tempered by Ruskin's love of Turner. Many were word paintings, which could be descriptions of Turner paintings. Let me quote one.

"It had been wild weather when I left Rome, and all across the Campagna the clouds were sweeping in sulphurous blue, with a clap of thunder or two, and breaking gleams of sun along the Claudian aqueduct, lighting up the infinity of its arches, like the bridge of Chaos. But as I climbed the long slopes of the Alban Mount, the storm swept finally to the north, and the noble outlines of the domes of Albano, and graceful darkness of its ilex grove, rose against pure streaks of alternate blue and amber, the upper sky gradually flushing through the last fragments of rain-cloud in deep palpitating azure, half aether and half dew. The noonday sun came slanting down the rocky slopes of La Riccia, and their masses of entangled and tall foliage, whose autumnal tints were mixed with the wet verdure of a thousand evergreens, were penetrated with it, as with rain. I cannot call it colour - it was conflagration. Purple and crimson, and scarlet, like the curtains of God's Tabernacle, the rejoicing trees sank into the valley in showers of light, every separate leaf quivering with buoyant and burning life; each as it turned to reflect, or to transmit the sunbeam, first a torch and then an emerald. Far up into the recesses of the valley the green vistas arched like the hollows of mighty waves of some crystalline sea, with the arbutus flowers dashed along their banks for foam, and silver flakes of orange spray tossed into the air around them, breaking over the grey walls of rock into a thousand separate stars, fading and kindling alternately as the weak wind lifted and let them fall. Every glade of grass burned like the golden floor of heaven, opening in sudden gleams as the foliage broke, and closed above it, as sheet-lightning opens in a cloud at sunset; the motionless masses of dark rock, dark though flushed with scarlet lichen, casting their quiet shadows across its restless radiance, the fountain underneath them filling its marble hollow with blue mist and fitful sound; and, over all, the multitudinous bars of amber and rose - the sacred clouds that have no darkness, and only exist to illumine - were seen in fathomless intervals between the solemn and orbed repose of the stone pines, passing to lose themselves in the last,

white, blinding lustre of the measureless line where the Campagna melted into the blaze of the sea".

Heady stuff, and we only want this sort of thing in small doses. Nevertheless, it makes a change from much of the arid prose of today.

One of the Inner London Education Authority's Institutes, evidently in a desperate state to get a lecturer, rang my house when I was in London one day. The Principal of the Institute asked where I was. The possible addresses where I could be found were given to him, with the most probable being the Nicholas Vilag Gallery in Devonshire Street.

I was there, and in the basement looking through portfolios of his beautiful engravings, when Nicholas shouted down the stairs "You're wanted on the telephone".

When I answered, a voice said "Could you possibly give a lecture tomorrow evening?"

"I suppose I could", I replied, and the Principal responded "Well, we would be very grateful. This class is on Art and Antiques, and we must admit they have been played about with. So far, we have found no one suitable".

They let me choose my subject, and agreed to come for me by car. At nine thirty the following morning a pleasant lady picked me up at East Croydon station, and drove me to the Institute. It was a typical school, and when I went in with the Principal there was a full class waiting expectantly. She whispered to me that she was going, and I was left to face everyone.

"What was your last lecture?" I asked.

Someone answered "A talk on painting", and on hearing this I heaved a sigh of relief, and said "Well, let's continue with that".

I told them that I was only a temporary lecturer, but at the end of the talk they said they would like me to come the following week. I went to the Principal's office and told her what they had said. It transpired there was no lecturer for the following week, so I did that one as well. To my surprise I found I was enjoying the talks...it was a relief from working at home in isolation, and I was able to solve certain problems when talking about them.

I must have lectured there for about ten years.

Eventually the time came when anno domini was creeping on, and it was necessary for me to retire. Officially, you are supposed to

leave at sixty five, but at this time I was lecturing at three and sometimes four of their Institutes, and going from one to the other was becoming a little irksome. Especially when I was giving three lectures in one day with a journey between each. In fact, I was rather glad when I finished. It had been a interesting time, I had enjoyed myself and, I believe I gave pleasure and useful information to my classes. One or two of the officials I encountered were rather stupid, but all in all it was a pleasant episode in my life.

I remember a dear artist, Wilson, a senior member of an Art School, whom I was honoured to count among my friends, saying to me "All life is meetings and partings". As the years go by, I realise how true that is.

I think it was Temple Thurston, author of 'The City of Beautiful Nonsense', who said "To lose a friend is to die a little". Again, how true. The last time I saw Wilson he was walking along Oxford Street.

After we had greeted each other, he said he was having a one man show in Sandersons in Berners Street, and added "I'd like you to go along. My son is holding the fort for me at the moment, so maybe you'd like to have a word with him".

I went to Sandersons and into the Exhibition Gallery, and there were his pictures on the wall, with his son in charge. Wilson's son and I exchanged a few friendly words, and then I looked at the paintings. I must admit that I wasn't too keen on them...the majority seemed to be composed of logs of wood. I found this rather strange, and wondered if he'd spent a holiday near a timber yard! Logs obviously fascinated him.

That's the only time I've ever been in Sanderson's Exhibition Gallery. This was around the same period that I was holding my one man show in Foyle's Art Gallery. Christina Foyle had invited me to show a collection of my works there. The local Croydon paper wrote the Exhibition up, and then the editor visited the gallery. There was, as I mentioned when talking about Captain Moller, a good account in the magazine Art Review, but I had no financial gain from the show. In fact, apart from the Royal Academy where I've been successful in selling my pictures, the other exhibition galleries were a dead loss. And, when you think of the cost of transporting your work to an exhibition, plus the hanging fee they require and then returning the unsold work back to you, it can be a costly business. This, of course,

has always been so. When Holman Hunt painted his 'Flight into Egypt', he asked Charles Dickens how much he thought he should charge for it.

Dickens replied "How much do you think?"

After some hesitation, Holman Hunt is supposed to have answered "I think it's worth five thousand pounds", to which Dickens responded

"Considering the time it's taken, and considering that dealers and publishers want the biggest share, I don't think that's an excessive price".

Pleased at the great man's advice, Holman Hunt left with a happy heart, and only on his way home did he remember Charles Dickens had not asked to look at the picture!

Charles Dickens moved in an artistic circle. He had a coterie of friends that included Clarkson Stansfield and Wilkie Collins, also Daniel Maclise, the loveable Irish character who was one of his greatest friends. Maclise painted the two large pictures that hang in the Houses of Parliament...one called 'Meeting of Wellington and Blucher after Waterloo', a vast canvas, although historically they never did meet like that. The companion was 'The Death of Nelson'. Maclise was an incredibly skilful painter, and could paint figures without a model in front of him. What a genius! His death was a severe blow to Charles Dickens, and at the following year's Royal Academy banquet when Dickens was guest of honour, he paid a moving tribute to his late friend.

When I was about fifteen my father, a typical cicerone of all these great painters, from time to time took me to look at the landmarks in his idea of historical importance. He showed me many pictures, and a fresco in the Houses of Parliament by William Dyce. Shortly after this I paid my first visit to the Tate Gallery, and for the first time saw pictures that remain in my memory, oblivious of passing fashions. Among them was Alma Tadema's 'Favourite Pastime', a painting of two nude figures splashing in a marble bath. I still remember with wonder the skill of that picture

I never did take much heed of fashion in art, because what one generation decries the next will hail as great pictures, and this has always been the case. One can only see the prices some Victorian pictures reach in the auction galleries, to realise that fashion is a fickle thing.

Only the other day, a successful portrait painter and exhibitor at various galleries, said to me "I'm not very interested in Van Gogh". Hence my remarks about Alma Tadema. I suppose that in a larger way morals - which do not affect art as art is immune from them - form some kind of a parallel. What one generation condemns, another condones. This observation also applies to the prevailing trends in modern society. For example, in the Diploma Gallery in the Royal Academy, there is a painting of a patriarchal figure who is turning his daughter out into the snow, and in her arms is a baby. I suppose the moral here is that the girl has erred, and according to her father she must look after herself. What claptrap! Let him who is without sin cast the first stone.

One has only to consider the vice and depravity that occurred in the Victorian age, to realise the hypocrisy of so much Victorian moralising. Swinburne, the great classical scholar and writer, frequented strange houses in St John's Wood where certain perversions took place. And the photographs of him at the side of Lola Montez, contrasting his weedy figure with her voluptuous stature speak for themselves. A strange genius, who Ruskin alluded to as the Demonical Youth.

When Swinburne was a protégé of Jowitt at Balliol, he was listening to a translation by Jowitt of a passage from the classics. Such was Swinburne's knowledge that, at one point, he interrupted the great man, saying "Oh, master...what a howler!"

Of course, he was reclaimed from his dissipations by Watts-Dunton, his solicitor friend. It has been said that Watts-Dunton stultified the genius of Swinburne. He took him under his wing and carried him off to his house in Putney, where Swinburne settled down into a quiet conventional life. I think we should remember this, and realise the degradation that might have been the lot of Swinburne, but for the loving care of Watts-Dunton.

In the days of his literary zenith, Swinburne was the associate of so many of the literary decadents of the time, culminating in the Fin de Sècle with Oscar Wilde, Aubrey Beardsley and that strange crowd. It seems to have been a kind of international 'Fleurs de Mal' by Van Huysum, combined with the eroticism of Baudelaire.

Not so long after that we get the Art Nouveau period with the brilliant drawings of Toulouse Lautrec, who, incidentally, did a drawing

of Wilde in a Parisian café. And again, the beautiful drawings by Alphonse Mucha of Sarah Bernhardt, one of the cult figures of France at the time of the Art Nouveau period. Germany had the same interest in the Jugenstil movement.

The logical continuation of that was the Secessionist Movement, which received a blow with the outbreak of the First World War. Then, in many ways, the world went wrong.

When Lord Grey, the British Foreign Secretary said "The lights of Europe are going out", how right he was, and this could also be a metaphor of the changing society. There is a saying that man throws his religion away after war. Although, in some ways, the carnage of the First World War was not repeated to the same extent in the Second World War the latter was, nevertheless, a staggering blow to civilisation. This is reflected in the extravagances of so much modern art, a lot of which is little more than hysterical expressionism that betrays the despair of modern society. Who was it who spoke about the pessimism of ultra sophistication?

When I look at a large painting by Rothko, although it does give me a feeling of repose, I must admit that it reflects the futility of much modern art. As do the pretty coloured pipes that masquerade as modern sculpture.

Another curious manifestation of the uncertainty of modern critics and art dealers, is the way they promote insignificant works by one time great artists that are little better than rubbish. They then sell them as works of the master, on the strength of their name. I have seen works bearing the names of Renoir, Picasso and Leger, that really are no better than rubbish but, on account of the names on them, sell for substantial sums of money. They are so poor, they would be neglected in any minor exhibition. Too often people don't buy pictures, they buy names.

I remember going into a commercial art gallery where all the fashionable 'moderns' were displayed, and an innocent lady came in and said "I want to buy a snow picture".

The assistant looked at her in a surprised manner, and shook his head. If she had said "I wish to buy a Picasso or a Braque" she would have been speaking the same language as the assistant. Once again, this illustrates the point...they don't buy subject pictures, they buy names of well known artists. This accounts for the notorious business

of the forgers. Forging the names of well known artists, even if the picture is inferior, seems to be a profitable activity. .

Here again, there is the example of the works of Corot, and the incredible number of Corots that exist in America. Even if he had sat up all night painting, he couldn't have produced the number of paintings attributed to him. Of course, one must admit that in the older schools of art, it is amazing how many pictures are supposedly painted by certain masters. There are, for instance, an astonishing number of large canvases by Rubens in all the principal galleries. But, in this case, we do know he had a staff of extremely competent assistants...artists in their own right...who worked for him. Even with the creative industry of his genius, it would have been impossible to have painted all the pictures attributed to him, on his own.

Another perplexing mystery of this kind is the case of Van Huysum, the flower painter. To paint a rose with the finish of Van Huysum would take a whole day. When you think that every principal gallery in Europe has exquisite examples of work by this flower painter, it would have been impossible for one pair of hands to paint the large number of pictures with their miraculous finish that are attributed to him. He was known as the prince of flower painters, and all the heads of Europe vied with each other to obtain examples of his exquisite art. He died in 1749, and although many flower painters followed him, he still remains supreme. Skilled as he was with his flower painting he seemed, however, to have lacked knowledge as an entymologist. In the fruit and flower painting by him in the Wallace Collection, there is a butterfly, sadly the worse for wear. Another detail about his work is the excellent condition the paintings are in. I suppose he was one of the last masters of the Dutch School.

We must remember that towards the end of the seventeenth century, the cultivation of flowers reached a very high standard. In fact, the cultivation and speculation of tulips became a scandal. Tulip bulbs would be bought and sold on the Exchange, not unlike the ridiculous speculation in tinned fish after the last war. Tulip mania became such a scandal in Holland, that the powers that be had to suppress the gambling. Tulips became a kind of cipher for speculation. Large sums of money would exchange hands without the tulips being seen. In other words, the gambling went riot.

With its cessation came the last flicker of the Dutch School, although there was a revival of interest in the nineteenth century, with the gifted Koek Koek family and, of course, the Post Impressionist, Van Gogh. I must admit to never being terribly keen on Van Gogh's work, although I remember one large painting by him which impressed me considerably. It was 'The Garden at Arles'. This was the place where the poor afflicted genius was taken care of. The picture is a large tree overhanging the garden...in fact, taking up the majority of the canvas. Great slabs of dark blue paint fill up the top of the canvas. Then, the final picture he painted which was so tragic...the cornfield with a path that suddenly stops and, over the top, ominous black birds flying. There is no escape from his mad frenzied thoughts. And Vincent Van Gogh killed himself.

The Kroller-Müller Museum in Holland has examples of his work, but you cannot expect a School to emanate from his paintings. The placid river scenes of Abraham Hulk and Koek Koek are more suitable for the Dutch temperament. I like the Dutch. I remember standing outside the railway station in Amsterdam...I wanted to go to the Rijksmuseum. I looked round, and there was a gigantic Dutchman with boots on that would have been suitable for a member of the Gestapo, and I went up to him and asked the way to the museum.

In a considered way he said "I will show you" and led me to the tram stop. And when the tram came he got on it, and spoke to the driver.

Then, he rejoined me, and said "This tram will take you". And the tram took me without any trouble at all.

I like trams...I'm sorry we no longer have them in this country. During my younger life, trams were the usual mode of transport in many towns and cities. Here in Croydon there was a tram that plied between the bottom of George Street by the Almshouses and the Black Horse by Ashburton Park. Quite unlike the monolithic routes today, where so many buses apparently lose their way, are rarely on time, and also nervously go around in twos, the intimate route from George Street to the Black Horse was extremely efficient. If you wanted to go to Croydon, you'd go to the tram stop and in no time at all a tram would come along. After the trams were no more, when I used to go to Croydon I walked. I wouldn't even consider waiting for a bus.

Trams also had cheerful drivers and conductors. It seems as though today they have chips on their shoulders. Once I was waiting for the tram after coming out of the cinema.

When it came along and stopped, the conductor put his head out, whisked his cap round so the peak was at the back, and sailor-like said "Any more for the boat train?" Such cockney humour is sadly conspicuous by its absence today.

Or, on the tram route to the Crystal Palace the conductor would shout out "Any more for the Ally Pally?" Such comments made for happy public transport.

Coming back to the trams between George Street and the Black Horse. Towards the end of its life, the track was a little worn. And near where I lived there was a loop in the line to allow the trams to pass each other...one going, and one coming back. The place where the points operated was a source of fascination to all those who knew this operation. As it came near this spot, knowing man that he was, the driver slowed down, and usually the wheels of the tram went in the right groove. If by chance they missed, the tram would mount the pavement. What a business that was! Driver, conductor and inspector would stand there contemplating the problem of getting the tram on the rails again. To children this was a source of great delight.

Cherry Orchard Road in those distant days was about half the width it is now. The little cottages on the other side of the road which I mentioned earlier...Park Cottages, built in 1838...and the pub next to them, The Cherry Orchard, a beer house with a green façade were there then. In the small beer house there was a public bar, a bottle and jug bar, and the saloon bar. And the little cottages had long front gardens. Now all memories.

My father's shop was a centre of brilliant conversation. He was inclined to hold forth setting the world to right, surrounded by a galaxy of clever men. And I, playing with my soldiers, would be under the table, not really playing but listening to the conversation which was taking place above me. I was about five or six at the time. I remember Venner, the electrical inventor, used to come, and one night he arrived with a companion, and both were in evening dress. The shop was lit by a fish tailed jet...we hadn't graduated to a gas mantle...and there was my father in grimy clothes, and with grimy hands, trying to make an obstinate grandfather clock perform.

He said to them "Let's go into the other room". So, in they all went, and began talking.

The conversation in the shop was quite varied. I have mentioned Venner and his friend...inventors in the electrical field. Then, there were two artists who used to come in...celebrated in their time, but forgotten today. And the medical profession, represented by one or two extremely capable physicians. And the dental surgeon, who was wasting a great deal of time evolving an instrument to register the unequal bite of a patient. I remember my father making drawings of this strange contraption, and towards the end of their discussions about it, the dental surgeon used me as a guinea pig and put it on my head.

What it did I have no idea, because he said when he looked at it "Oh dear, it's not registered as I thought it was going to do". He was sure this invention would revolutionise false teeth, but it was a failure. It should have developed in the same way as the extraordinary inventions that had been exhibited at the 1851 Exhibition. Here was one, however, that did not make the grade.

This dentist also invented a drill which he tried out on me. The pain was excruciating...the drill might have been useful for drilling bricks, but not teeth.

After the ordeal was over, he said "You are stamping your foot on the chair...you must be nervous".

I must say that he was a very nice man, but despite the fact he was a qualified dental surgeon, I often wondered how he managed to practice! His drill was bad, and his instruments must have been antiquated.

I did once have a catalogue of surgical instruments, going back many years. Some of them that were used in childbirth, for example, were terrifying! One, used in confinements, had the handles covered in sheep's wool. Many women must have contracted fevers and disease from this, perhaps with fatal results. There was a case of a surgeon who attended a woman who died of puerperal fever in a hospital ward, and then he went immediately to deliver another child. The need for antiseptics and cleanliness didn't seem to enter their heads in those days.

Of course, less than a hundred years ago the extraction of a tooth was a terrifying experience. As was the amputation of an arm or a leg at the time of Nelson. Someone once said that the greatest pleasure

in the world is the cessation of pain. How blessed we are today with modern science and surgery.

In Nelson's day, when a man was discharged from the Navy because of his wounds, considerate authorities gave him permission to beg. Vagrancy laws were strictly enforced in those days, and the fact he was allowed to beg for a living was the privilege (!) of a wounded serviceman. At the time of the Napoleonic Wars, when a wounded sailor was carried down into the cockpit to have his wounds attended to, the scene must have been something like Dante's Inferno. Screaming soldiers and sailors writhing about in their agony, the only illumination coming into the darkened room from a swinging lantern, and the floor of this primitive hospital painted red like the deck, to disguise the blood.

Another great hardship for sailors in those days was the reefing of the sails. The men had to walk out on the yards in their bare feet, and reef the sails in all weather. Their sails would break, and the sailors often fell. That is why so many of them had a wooden leg. Not long after this came the first surgeon on a 'Man o' War' to introduce a truss for the many sailors who were ruptured, reefing those heavy sails. The traditions of the navy may be very heroic, but the glories of Trafalgar were hard paid for.

Talking about Trafalgar, a lady collector I knew had two magnificent model ships. One was a thirty gun frigate of the time of Trafalgar, the other was a French vessel made by one of the prisoners of war. With regard to the second, it was a magnificent model and perfect in every detail. I called it a prisoner of war model, because during the Napoleonic Wars the French sailors who were captured made these models during their incarceration in this country. Today the models are highly desirable collectors' items. Principally, the models were made from the bones which the prisoners preserved from their victuals, and other parts were made from the straw in their mattresses. Some of the ingenuity was incredible...they even made a form of machine that would split the straw they were using.

The lady I refer to...a Mrs Wren...was a dancing mistress. When I knew her she was considerably advanced in age, but still very active. She would demonstrate to her students certain steps, throwing her legs in the air in a most preposterous way, with scant regard for propriety. There was a nervous old lady who played the piano during

her dancing lessons, playing most vigorously as though her life depended on it.

And, every now and then, Mrs Wren would turn round with a glare, and shout out "More brilliance...more brilliance!"

My acquaintance with this extraordinary character was because of our mutual interest in antiques. She had a remarkable collection. Her home was rather small, but the front room and the hall approaching it were packed with treasures. She obviously bought with great discrimination. I know this from personal experience, because I sold her one or two things, and she drove a very hard bargain. Lady antique collectors are well known for their sharp dealings. Lady Schreiber, who married a wealthy iron master, and whose wonderful porcelain collection is now in the Victoria and Albert Museum, was notorious for driving hard bargains when she bought magnificent pieces all over Europe. One of my delights is looking at these treasures...she very public spiritedly left the collection to the nation. But I digress.

The other ship model Mrs Wren had was a beautiful 1805 Man o' War. These models were frequently made by sailors who knew all about rigging and the technical details of a sailing ship.

Amongst her many treasures, on the mantelpiece were some exquisite examples of early glass, and, in pride of place, a Baccarat or Clichy paperweight...I forget which. I do, however, remember that when I was quite young, she bought this paperweight from my father, for thirty shillings (£1.50). Of course that would bear no relation to today's prices.

That story brings to light another about paperweights, told to me by Old Sussex, the watch and clock man. When I knew him he must have been well over seventy, so all this happened many years ago.

He was on a bicycling holiday in Devon, and the day being hot, he dismounted from his bicycle and walked to a cottage and went up the garden path. Knocking on the door, he asked the lady who answered if he could have a drink of water. While he was drinking he looked down the garden path, and to his amazement saw that on either side of the path, instead of the usual flints, were paperweights.

He commented on how unusual this was, and the lady replied "Oh, I put little value on those. My husband was a traveller in paperweights, and these in the path were some of his samples."

Old Sussex then asked if she had any more.

"Yes, I've got two boxes in the bedroom," she replied. "They were all his samples."

She left him and went upstairs, returning with the boxes. Each paperweight was individually wrapped. Old Sussex then asked whether she would consider selling them. She hesitated, and he offered her a fair price. She agreed, and he put them in his bicycle bag and returned home.

Old Sussex then sold them to an antique dealer. Subsequently, he returned to the cottage, and purchased the paperweights that were on either side of the garden path. Their value today would be very difficult to assess.

Remembering the many wonderful things that Mrs Wren had, one can understand with what joy and pleasure she regarded them. To all collectors of antiques and works of art, the acquisition forms a kind of palliative to the stresses and strains of modern life. Not only in minor collections, but even the great people of the world have required some form of moderator in their lives. One can recall the death of Mazarin, Cardinal and chief minister of France. He had a tremendous love for pictures, and, no doubt, when his affairs of state or an interview with Louis XIV were over, he would retire to his own apartments and look at the masterpieces he possessed. And when, at last, as a sick man - and he knew it - he walked into his picture gallery...the story is told by a footman who was discreetly hidden behind a curtain, and saw Mazarin stumbling between his rows of paintings.

He then looked up at them and said "Goodbye pictures." As Shopenhauer said, the arts are palliatives to existence.

The same applies to us 'lesser' beings. Like Mrs Wren, for instance...she had the right idea. I can remember that wonderful small room of hers, and the lid of the upright piano, which was covered with a wonderful collection of china cats. I am not talking about 'A Present from Margate', or some geegaw from a Sale of Work. These were wonderful examples of large Staffordshire pottery. There was also a beautiful papier-mâché tray with a coaching scene on it. She also had a fine collection of Staffordshire animals, quite apart from the cats I have already mentioned. One day she came into my shop with a tray of paper badges that she was selling in aid of the Canine Defence League. Needless to say, I bought one of the badges, which I put on the counter

and mislaid. We started talking about the various things she possessed, and those she would like to possess.

Knowing this was her weakness, I said "Have you seen my giraffe?"

Instantly, she was all ears. "I want a Staffordshire giraffe. I've seen them, but never had one".

With some mischief I said "Come and look at mine".

She did so. "What do you want for it?"

"It's not for sale," I replied.

She tried everything to get me to sell this giraffe.

"No, Mrs Wren, I'm not going to sell it. I love it so much."

And, just then, the telephone rang and so she left the room with these parting words. "Well, I'll go now, but I haven't forgotten the giraffe". I thought of Lady Schreiber, and remembered reading about her persistence in getting things she wanted.

A week later Mrs Wren appeared on my doorstep, and said "I've brought my basket to take the giraffe".

Needless to say, I didn't sell it, but these are the pleasant tales of our household gods. The lares and penates of Mrs Wren's existence!

She used to say "When I die, I shall be quite happy if I can do so among all these things I've got".

Mrs Wren was a remarkable woman. She always gave the impression of being full of vitality. Then, of course, comes the sad part of this story. As I've said before, I always left her house with happy memories of the beautiful treasures she had collected. But, one day, the sad news came that she had been upset by two villains. The story was related to me by a mutual friend. Evidently, Mrs Wren had been out shopping, and she'd only been indoors a short while, when the front door bell rang. I can visualise her walking in her usual brisk manner, and opening the door.

Two men stood on the doorstep, and one said "We are very sorry, madam, but there has been an accident. We kicked a stone on the path, and as you can see it has broken one of your window panes. Can we come back later this afternoon, and replace the glass?"

Mrs Wren agreed to them coming back, and when they returned and she let them in, these evil men knocked her down, tied her up, and stripped her home of her beautiful collection. Subsequently, a shop nearby was implicated in receiving stolen goods.

Poor Mrs Wren never recovered from this dreadful experience. Sadly, I never saw her again.

The difference between meum and teum...these appalling creatures think what's yours is theirs. Some years ago, two men came into my shop. One of them looked at an article in my glass showcase, and asked if he could see it. As I bent down to get it, he struck me. I was more surprised than anything else. I fell down, but instantly jumped up, shouted at him, and started fighting back. His companion, a fellow with dark crew cut hair, picked up the chair and started coming towards me with it. It all happened very quickly.

The one who struck me said "We want to get behind the counter", and I started resisting him. There were several blows struck, the plate glass counter was broken front and top, and realising it was proving not so easy, they both fled. I noticed some blood on the door, and drawing my handkerchief across my face, found there was blood on that too.

I dialled 999, asked for the Croydon Police, and told them what had happened. It seemed, unlike today, that within a few minutes the shop was full of policemen. After a while they left, then the phone rang, and it was the police once more. I had given them descriptions of the men...one with a crew cut, and the other wearing a pale new overcoat and a cap. The police had found someone answering to one of these descriptions, and at ten thirty that night I was asked to go to the police station to make an identification.

I went there, and the detective took me downstairs where a row of men were standing in an identification parade. I was asked to look at them carefully.

I soon picked out the man in the pale grey overcoat, and then asked where his accomplice was. At that time the police didn't know, but I was later asked to go to Scotland Yard to look at some photographs. Going through the albums which were placed before me I must say that I have never seen such a collection of evil looking faces. One by one, I turned the pages over, but there was no sign of the man I was looking for.

I continued looking and this took some time, but still did not see the man and told the police so. Now, what I'm going to relate speaks much for the efficiency of the police. As they took the last album away, they showed me one photograph. It was the other man.

The first man I had identified had been a physical training instructor at a school, who had obviously gone to the bad. His companion, the dark-haired fellow, was supposed to be earning a living in a boxing booth.

Subsequently, the police rang and said I should have to attend the Quarter Sessions in Kingston. I arrived at the imposing looking building, and as I mounted the stairs, two heralds sprang to attention and blew a fanfare on their trumpets.

I thought "This is the way to greet me", but on looking round saw coming up the stairs at the back the Sheriff of Surrey. Feeling deflated, I went inside the building and made my way to where I was told to go.

Eventually, I was ushered like anybody else into a courtroom. Presently, the men who had tried to rob me were in the dock. I listened to the defence of these petty villains, was asked to answer a few questions, and then dismissed. I left the court, and caught the bus back to Croydon. Even now, I don't know what happened to them, but that was the end of the episode.

Prior to the attack in the shop and my visit to the Quarter Sessions, there was a robbery that took place in my house.

Early one morning my sister came running up the stairs, and burst into my bedroom, waking me up and crying "We've been robbed!"

I rolled out of bed, put on my dressing gown, and cried "What do you mean?"

Coming downstairs a dramatic scene awaited me when I opened the door of the living room. The lights were on, and the two eighteenth century candlesticks with their wax candles were also alight. Piled up on the floor were the drawers that had been taken out from the chest, the bureau, and my mahogany writing desk. And like toothless holes, there were many gaps on the mantelshelf.

I immediately telephoned the police, and when they came I spent some time answering their questions. This turned out to have been a devastating burglary. Shortly afterwards, I was asked to attend a court. In the dock was the villain who had obviously perpetrated the crime. After the usual formalities, I described my side of what had happened, and following the completion of my evidence, was asked to go forward and stand in front of the Magistrate's Bench.

That most important gentleman leaned forward, looked down at me and said "Thank you...I congratulate you on your evidence". And I returned to my everyday existence.

It would seem, on reflection, that I am burglary prone. Serious as the burglaries I have already mentioned were, they pale in comparison with one of the most recent. This took place on a Wednesday evening.

I was out lecturing that night on art and antiques, and just before this burglary I had shown some of my possessions to a man, and told him I was giving a lecture on the Wednesday evening. This man knew my movements, and that I lived alone. When I came back on that Wednesday night after giving the lecture, the place was in darkness and the burglar alarm had been ripped out. I went downstairs and found the back door had been smashed in and was lying on the floor. But, worst of all, my magnificent collection of silver had been stolen. This included vinaigrettes, many small and rare items, a collection of Irish silver connected with the Kildare Rifles, and some magnificent early Georgian basting spoons. So many other large and important items were stolen, it is difficult to enumerate them. I also lost all my wonderful carriage clocks, and a number of fine bronzes, including one of two little boys playing leap frog, something I especially loved.

When the police finally came and had gone through the usual formalities, just before they left they asked if they should make the back door as secure as possible for the night.

I said no...leave the door on the floor. I had some idea the burglars might come back, and I would be ready for them. When I got to bed, however, I felt slightly uneasy when I suddenly realised how vulnerable I'd be if I was in bed when they came! I managed to get some sleep, because the full shock of what had happened did not hit me till later. Sometimes I think I know who did it, but who can really tell? Sadly, none of what was stolen was ever recovered.

But this is all behind me now...life goes on as before. Lay not up treasures on earth...although this seems a little hard on collectors!

Some years before all this happened, I started having trouble with an eye.

I sought the advice of an ophthalmic surgeon that I knew, and he looked rather serious and said "I'd like to show this to a specialist in

London". As my eyes were very precious for my work, this caused me some worry.

I made an appointment to see this London specialist...a very fine man...and after a careful examination he said "If you were in America, they would take that eye out straight away. But, we do not do things like that in this country. Come back and see me in a year's time".

As my sight was perfect I forgot all about it, and after a year's work, I went and saw him again.

He gave me another examination, then said "Come back in a year's time". After the third year, when he said exactly the same thing, I began to think I had the sword of Damacles hanging over my head. I forget how many years I went backwards and forwards to see him. In the meantime, the ophthalmic surgeon whom I knew had asked me to attend a conference in Croydon, where there were a number of surgeons who all seemed to take great interest in my eye.

Returning to my London specialist, he said "I would like you to go to hospital to show your eye to another man who knows a lot about this sort of thing".

I arrived at this hospital to find a doctor at the gate waiting for me. He took me inside and ushered me into a room where a certain well known specialist was waiting...he was subsequently blown up by an IRA bomb.

After looking at the eye for some time, he said "I'd like you to show this to a specialist at Bart's. I'm going to America soon, but when I get back I'd like to be at Bart's at the same time".

I returned home and waited for my next appointment.

In the meantime I had another visit to the two specialists, in Chelsea. I was told I should go into hospital and have a minor examination, which I did. This was for a biopsy. There was nothing to it, and when I came round I walked about the ward.

Presently, a lady came up to me and said "I'm to take you downstairs again". We started talking, and I asked her what her name was.

She said "Praga".

"You must be something to do with Anthony Praga."

"He was my husband", she replied.

I remember Anthony Praga...he was a very distinguished journalist. Also his father, Alfred Praga, was the President of the

114

Miniaturist Society. She seemed very excited that I knew them, and I remember quoting a rather humorous story about these two men. It was the time when there was a cause célèbre about a painter, who had committed suicide over an attractive model. The man in question had been an artist of some promise, and then he fell for the charms of this lady. It was in all the papers at the time. I can't remember whether the two of them committed suicide, or only one. Be that as it may, Anthony Praga wrote an article about the affair, and not quoting verbatim, implied that the young artist, like all artists, was half-witted.

This remark prompted his father, Alfred, the artist, to reply "If all artists are half-witted, then my son must be the other half wit".

I believe the lady at the hospital quoted that to the specialists, because after that I seemed to be treated with more familiarity!

A few days later, I returned to the hospital for another visit to my specialist.

After examining my eye very closely, he walked over to his companion who was sitting at a desk, and I heard him whisper "It's got to come out...are you going to tell him?"

His companion rose from his chair, came slowly towards me and said "We've nursed you for a number of years, and I don't think we'd better leave it any longer. You'll have to lose that eye".

I said "I don't think I want to", and explained my various activities, adding "I'll bid you good day".

When I got back, to confirm what I had said, I wrote a letter to the specialist. Previously he had said that if I didn't lose the eye, it might prove fatal. I said I would prefer to keep my eye.

He would have received the letter next day, as very late that night he telephoned and said "I received your letter, and you can't talk like that. I want you to go to Mr Bedford at Bart's. He's the top man in the country. See what he says. He's expecting you tomorrow".

A lady friend took me up to Bart's, and I went to the Eye Clinic and saw Mr Bedford.

After examining me he said "You're sitting on a volcano. You must come in and have the eye removed. I understand that you don't want to lose the eye, but you've got to".

I came home feeling rather worried, but decided that I would have to agree to the operation, and went back again next day for a further consultation. Soon after this, I went into hospital. They were

very kind to me, and put me in a room on my own. I can honestly say I was completely without fear.

I had a good night's sleep, and next morning told the nurse that I was not certain that I liked the solitude. So I was transferred to a ward with three other men. This was much better, and after chatting to them, that evening two male nurses came and I was given a 'pre med' injection, and following this was wheeled to the operating theatre. As they took me down, I found myself laughing at the remarks the two nurses were making about a girl with a short mini skirt. After an injection in my arm, I remember no more.

One thing I should have mentioned before this...I told my sister that I didn't want anybody to see me for three weeks. I had read about Sir Alfred Munnings, who had one of his eyes torn out going through a hedge. Apparently, his eye was bound up for three weeks after that, so it seemed it would be the same for me.

I came to in the early hours of the morning, and felt sick. A female nurse then brought a small bowl.

She had a beautiful face, like a Rosetti painting, and I said "Aren't you beautiful". She smiled, and I knew this pleased her very much. Then I went to sleep again.

About half past five, the nurse came and washed my face, gave me a cup of tea and said that I could get up.

I seemed to take it for granted that I could see, then passed a hand over my face and realised that one eye was bandaged up. I felt quite well, and after shaving myself went to the end of the corridor where there was a telephone. I knew my sisters would be waiting to hear from me, and when I telephoned could tell how excited they were. After their enquiries about my health and my reassurance, I remember saying to them "No more than having a tooth out". In spite of everything I was grateful to have one good eye.

I was in hospital about a month. After a few days, I asked whether I could go out...I wanted to test my monocular vision in the busy streets of London. Satisfied I could see all right, I returned to the ward in a philosophical mood. On the following Sunday, I went to church with a fellow patient...the historic church near Bart's...and heard an interesting sermon on the frailties of humanity.

The fellow patient was an amateur photographer, and he took several photographs...particularly of the pretty nurses. The sister of the

ward had a reputation for being something of a martinet, and when I left I gave her some flowers, which I think she liked.

I have nothing but gratitude for the treatment I received from the ophthalmic specialists, the sister and the nurses of that wonderful ward. I was also amazed at the number of well wishers who sent me letters and cards during my stay, a stay which, incidentally, coincided with my birthday. I was deeply touched by all the good wishes I received.

When I came home, the top of the piano and the mantel shelf were also filled with cards, and there were vases of flowers everywhere. Welcome home!

CHAPTER 8

Cats and a dog,
wartime and £17 for a Monet

It's curious whom one meets in life. Charles Dickens produced some fantastic characters in his books...I am certain they were based on real people he had met. When he was a cub reporter, he must have seen many extraordinary individuals in the Courts, and no doubt he used them and exaggerated their peculiarities.

When I was a boy, I sized up so many of those who came into my father's shop. Each had an individuality that fascinated me. They would come in and talk to my father...looking back on those days, he wasted no end of time gossiping! They and he did their best to put the world to rights.

I have mentioned earlier about my supposedly playing under the table or counter with soldiers, but really listening to the words of wisdom being uttered above me.

Talk ranged from the highest level of conversation, to the dregs of rubbish. In one of these I remember a brief interview my father had with Gandhi. That was during the time when Gandhi was a student in this country. In fact, my father seemed to have a kind of magnetism that attracted students of all political and artistic leanings. They would come and talk to him, airing their views on all manner of subjects. Sometimes the conversation was placid and well mannered...at other times voices were raised, and altercations were the order of the day.

In those days, the Imperial policy of this country towards India caused Gandhi to become very excited. I remember the table above me became quite agitated by his thumpings.

Then there were interesting arguments about art...for instance on the pros and cons of modernity against the academic approach to the subject. One fascinating discussion was about the involvement of Millais with Effie Gray...Ruskin's one time wife. Stories concerning that strange affair were related to my father by one of the Bond Street dealers. One that particularly intrigued me was told by another art dealer, to the man who repeated the story to my father.

It appeared that this man used to frequent a gallery in Bond Street where Millais was also an habitué. After the cause célèbre, the divorce of Ruskin and Effie Gray was granted on the supposed grounds that the marriage was never consummated.

After Effie had married Millais, he, Millais, was in the gallery one day, and this man heard him say "I soon showed her what a man was".

Effie became a happy wife, and bore a number of children. What is surprising about the whole of this dramatic affair is that when Ruskin wrote 'Praeteritor', his autobiography, and possibly his most beautiful book, despite the fact that he included many details of his long life never once did he mention Effie Gray.

This charming book is the only one Ruskin ever wrote to give pleasure, rather than dictating to people on what they should do. Gradually this fine intellect became clouded, and the last years of his life make sad reading.

Turning to happier things, I must talk for a little while about my household pets.

One remembers the words of the Victorian cleric and wit, Sydney Smith, who said he wouldn't give a farthing for a man's religion, if his cat and dog weren't the better for it. I may not be so deeply religious as I'm sure Sydney Smith was, but I certainly love my pets.

There have been many, all with their own individuality. Cats have been treated quite seriously in this house, and they come and go like shadows from the past. All had their own names, from the loveable Donkey...because she had large ears...to Sleepy Eyes, who always looked as though she wanted to go to sleep. Leo, who came as a stray, and even when tamed had a voracious appetite, seemed to be partial to

eating snails. Possibly he had spent some time in France! Then there was sweet little Gazelle...oh, she was a charming cat who walked in out of the cold, and eventually became quite tame. How they came and went, each giving us pleasure, and themselves refuge from the harsh realities of life. The only thing we thought necessary was to have the stray cats neutered. The names we gave them were so idiotic, but to us each was an individual little life. We had one tom cat we called Benjamin. I'm certain, if he had not been castrated, we would, indeed, have had a Tribe of Benjamin.

Then there was my little dog, Pat. My grandfather bought him in a pet shop in Surrey Street. When he arrived in a basket, grandfather looked rather agitated. It seemed he had bought the puppy, and then gone on to the library. Grandfather was a great reader, but he was also very deaf. He evidently took the puppy in the basket into the library with him. It appears that my grandfather was quite oblivious to the yelping in the basket because, of course, he couldn't hear him. He began to read a book, and soon the silence was disturbed by the cries of the puppy.

Eventually, someone complained about the noise in the aforementioned basket. The library assistant then told my grandfather he must leave the library. Despite raising his voice, the assistant still could not get my grandfather to hear him. So, the assistant started ushering him towards the exit. This seemed highly insulting to my grandfather who exploded in temper, and said he had been a member of the library for many years, and paid his rates to keep it going!

This storm in a teacup, which I heard about later from a friend who was in the library at the same time, was forgotten when my grandfather opened the basket and lifted the little mite out. His face wreathed in smiles, grandfather held out this little treasure to me.

I asked why he had bought the puppy, and he answered that as it looked so miserable in its cage, he thought he'd like to give it a good home. I then inquired about its breed, and was handed a scrap of paper.

In an illiterate hand was written the word 'Celium'. Despite this mysterious ancestry, Pat grew up to be a lovely companion.

When my father was alive, it was his duty to take Pat out every night, and when my mother went shopping in the morning she would take the little fellow out with her. Of course, in those days traffic was nowhere as intense as it is today and sometimes Pat would manage to

slip out before my mother, and he knew the shops she patronised. And, with the trusting nature of a pet, he would sit in one of the doorways of those shops waiting for her.

When he was put to sleep, it was a very sad affair. Grandfather had brought this little speck into the house, and by the time Pat died I had already lost both my grandfather and my father. So that meant I had lost my boyhood, and so much happiness that I'd experienced in those thirteen years. It's good to remember past happiness, but for various reasons I never had another dog.

In those days, as I've said earlier, Cherry Orchard Road was almost a self contained unit. Butcher, baker and candle stick maker...whatever you wanted, you could get it in Cherry Orchard Road. Next door to me was a butcher, and on the other side of the shop was the Animal Clinic...a branch of the Canine Defence League. They came just before the beginning of the last war, and when war broke out, I was most distressed to see the number of people who brought their animals to be destroyed. I vividly remember a church worker, whose metaphorical halo must have been much greater than mine, having no compunction about putting her household pets to sleep, because she wanted to go on holiday.

On the other hand, the butcher was of the old fashioned kind, with a dog cart and pony which used to deliver meat to the more prosperous customers. He was a great supporter of the annual horse fairs. He had a nice chestnut horse with four white socks, and on the day of the annual show, the horse was groomed and the dog cart had its wheels covered in paper flowers. And the young man sitting in the dog cart was trained to perfection as regards deportment, with his head slightly on one side, straw hat, and a freshly laundered coat. After all this effort, the butcher was usually successful as far as prizes were concerned. The horse fair was another of the old customs that were swept away with the outbreak of the Second World War.

My war work was principally with instruments for submarines. I was interviewed by a military officer, and had an interesting conversation with him although it had little to do with the war. But he was very interested in Georgian bracket clocks. He asked if I could drive a car, speak French, along with a few seemingly irrelevant questions. Then we both stood up, and shook hands. I thought this was very pleasant for such a formal man.

Then he said "We will let you know".

After that, they must have forgotten, because I heard no more. A friend of mine was engaged on instrument work, and he suggested I went with him. The job entailed working from seven thirty in the morning till seven at night. Also, I did ARP duties three or four nights a week until midnight. At the same time, I was winding up my own business, which caused certain difficulties. I was also worried about my mother, who was seriously ill. She had, prior to that, burned herself on an electric stove. It was a grim time, which included the near miss by the bombs on the premises, which I've already mentioned.

Coming back to the incident of the electric fire, soon after this all electric fires had to have grilles fitted over the front, by government decree. Before that, there were just open bars on the fires.

On one occasion after a heavy air raid I was talking to a man I'd never met before. His job was to examine anti-personnel devices which were being dropped by the enemy. He was looking for one that was supposed to have dropped near the top of the road.

He said "We'd better crawl...otherwise it may go off".

By dim torch light, we crawled along the ground, and finally found it. But it turned out to be a false alarm. What we found was not an anti-personnel bomb at all, but something far more innocuous.

The pleasant time during this period was the ENSA concerts.

There was a movement called 'Music For War Workers', and a meeting was convened in one of the rooms at the large factory. I think it was a man named Walter Legg who was chairman of the meetings, and we started discussing the pros and cons of the concerts that we might have in the near future. One or two voices were raised and started talking on political issues. Not agreeing with the substance of the remarks, this being a meeting concerned with music for war workers and not politics, I raised my voice and reiterated this fact.

Mr Legg looked across at me, and said "What is your name, sir?"

I gave him my name, and he responded by saying that it sounded like a motor car.

After some discussion, it was decided there should be a committee of four to formalise the various suggestions. I was one of the four chosen.

There were many interesting concerts arranged. These took place in the canteen in the factory. Coinciding with this development, there was also, at the factory, quite an active amateur dramatic society. Somehow or other I was conscripted into that concern, and did write a musical play for them to produce. There was an amazing amount of talent among the factory workers.

Two girls had very beautiful voices...but one was a more serious singer than the other. Of these two, one girl took part in the musical production, and the other sang a number in a different production. She sang 'Songs My Mother Taught Me', and I accompanied her on the piano. The audience loved it...she really had a lovely voice.

There was a man involved who I believe was Jewish, although he merely said he was a Pole. He had been in a concentration camp. Here I must digress for a moment.

After the war, this man started a job as a jeweller...it transpired he had been a practising jeweller. He was also a fine cellist...it's amazing the talent that appeared in the most unexpected places.

One of the members of the committee, when we were arranging the concert, asked "Can you play 'The Swan' by Saint Saens?"

"Yes, of course I can" he replied.

I accompanied him on the piano, and he played it beautifully.

Subsequently, I became quite friendly with this man, and after the war, as I have said, he started up again his previous vocation as a jeweller. I frequently visited him in his workshop, and he did several jobs for me.

I remember going to see him one afternoon, and waited while he finished the job I'd gone about. While he was working we went on talking, and I noticed how thin his hair was, as he bent over the bench.

With the familiarity of a friend I said, jokingly, "Not much hair left."

He put down his tools, looked up at me, and replied "I was in a concentration camp, and lost it all in a day".

It transpired he wasn't a Pole...he was a German Jew.

He was a fine craftsman. I had a very small enamel portrait of Shakespeare...little bigger than the size of a finger nail...and I asked him whether he would make me a ring to incorporate the miniature. I suggested surrounding the miniature with pearls. This he did, and he

made a beautiful job of it. The following Christmas I gave it to my sister as a present.

Eventually I lost touch with Michael, the jeweller, and believe he subsequently suffered a heart attack. I never saw him again, because like many Europeans he kept very much to himself and his own religions and persuasions. He had friends of his own who followed the same religion as he did.

I recall with pleasure some of the happier times we had, particularly the musical evenings when my sister played the violin, Michael the cello, with myself at the piano. Delightful gatherings and tender music, the music of friends.

My friend was also a friend of the members of the illustrious Amadeus Quartet. I believe they were interested in one of my pictures, and subsequently I think Nicholas sold the painting to this brilliant group. Michael was also a friend of Louis Kentner.

There was another virtuoso cello player I met at Nicholas' gallery... he was one the numerous people who frequented this place. I can recall going to the salon one evening, and George Mikes, the Hungarian writer was there and also this cellist. A charming man, quite young and destined for a brilliant future. Alas, he died soon after, and his mother wrote a touching letter to Nicholas, saying how much her son had enjoyed meeting Nicholas and his friends. As I've said before, all life is meetings and partings.

It's amazing the people who frequented Nicholas' gallery. Mrs Epstein, the wife of the great sculptor was another habitué.

I remember taking a party of students to Apsley House, the London residence of the Iron Duke. It is, indeed, a fabulous place filled with mementoes of the Duke of Wellington, and gifts that were given him by grateful nations. One must remember the wonderful collections of Old Masters on the walls. Spoils that Napoleon had sequestered, at that time, from those he had vanquished...the baggage train loaded with treasures for France was intercepted, and came into the possession of Wellington. Eventually the pictures were to be returned to their rightful owners but they, as a gift and with grateful thanks, allowed the Duke to keep the paintings. If you go to the great gallery in Apsley House, you can see these wonderful masterpieces, including 'The Waterseller' by Velasquez, and such an embarrassment of riches it is impossible to mention them all.

One recalls the 'Agony in the Garden' by Correggio. Not a large picture, but with a movable front to the frame. When the Duke was looking at this picture...which was his favourite work...he would take a silk handkerchief from his pocket, and very delicately dust the surface of the painting. A theatrical action, which must have impressed his staff. There is also a large painting of Wellington on a horse. I don't think much of it, and believe the figure of Wellington was superimposed on a previous rider.

The story goes that when Wellington first saw the picture, he was not very impressed.

There is a personal aside about Wellington. When my great grandmother was walking along a street of Georgian houses...I do not know where this was...she heard the sound of a horse coming along the road. It stopped outside a certain house, which had some steps leading up to the front door. My great grandmother, then a little girl, looked inquiringly at the great man on the horse. He smiled at her, and pointed to a particular house. He indicated that he would like her to knock the knocker on the front door.

This she did, and as the child tripped down the steps again the Duke smilingly bowed to her and said "Thank you, Missy".

In Apsley House there is a painting of Wellington leaving a building when he retired, and in Park Lane there is a great nude figure of a man, possibly Mars with a shield, erected in memory of the Duke. When the figure was erected many people were shocked by the size of the penis, and it was decided that a fig leaf should be placed over the offending organ. Subsequently the leaf was removed at the dead of night, once again exposing the sexual organ in all its glory. And then, alas, to stop further trouble, the powers that be decreed that the poor giant should be castrated, and the leaf replaced.

Coming nearer to home, that reminds me of a very fine bronze bull I possessed, modelled by one of the well known animalier sculptors. It was a very, very fine model and casting, and I placed him in a position of honour on my grand piano. It gave me pleasure to look at him while I was playing.

Alas for the noble creature, my sister did not approve. The sight of his genitals upset her so much that I was forced to sell the figure to placate her sensitive feelings. I don't suppose Wellington agreed to do the same with Napoleon at Apsley House!

London is filled with statues, good, bad and indifferent. The statue of Napoleon by Canova in Apsley House is very fine, and then one can think of the equestrian statue of George IV in Trafalgar Square, where the royal monarch sits astride his horse without stirrups.

Of course the finest statue is that of Charles I by Le Sueur which faces Whitehall. As I have previously mentioned, that was saved by the scrap dealer boarding it up during the time of Cromwell, and keeping it for happier times. Thornycroft's group of Boadicea by Westminster Bridge is also excellent, as is the Quadriga at Hyde Park Corner by Adrian Jones.

I dislike General Smuts by Epstein near the Houses of Parliament, where he is portrayed leaning forward. He must have had pins and needles in his leg. But all of these are overshadowed by the Wellington Memorial in St Paul's, by Alfred Stevens. This is supposed to be the finest memorial monument in the country since the memorial to Henry VII by Terrizane, erected by Henry VIII in memory of his father, and one of the glories of Westminster Abbey.

Nor must we forget, on a lighter note, Frampton's statue of Peter Pan in Kensington Gardens.

Frampton was the grandfather of Meredith Frampton, the Royal Academician. A year or two before the latter's demise, the Tate Gallery honoured him with a one man show. He drew with the perfection of Ingre, and I shall never forget his magnificent portrait of the Bishop of Exeter. It is one of the most outstanding portraits of recent years. So many artists today forget technique, relying on their so called vision. When Meredith Frampton died there was the usual small collection of his works on show in the Royal Academy. A posthumous tribute, but it was in one of the side galleries...very, very muted.

Now we are considering honouring another great Academician. The picture by Turner of Folkestone, formerly in the collection of Lord Clark, and which he called one of the finest pictures in the country. Rather debatable. Today the figure of many millions of pounds is being bandied about...when will the ceiling be reached with these fantastic prices?

Similar incredible sums are paid for Van Gogh paintings. Of course, Van Gogh was almost obscure at the time he committed suicide. The relationship between him and his brother Theo was something rather sublime. I suppose it was the money Theo sent him that allowed

126

Van Gogh to go on painting pictures nobody wanted to buy, and they piled up under his bed. A sad story, particularly when one thinks of what they are worth today.

On the other hand, the story of Turner was quite different. He had patrons who would buy pictures from him, and he was an excellent negotiator. As an example of his business acumen, or perhaps meaness, one can recall an oft quoted story.

He sold a painting to Lord Egremont of Petworth...one of his faithful admirers and patrons. Turner was staying at Petworth, and after dinner Lord Egremont passed a banker's order to Turner to pay for his last purchase. No doubt it was for a substantial sum, and Turner looked at it without saying a word.

His Lordship asked, "I trust the sum is correct?"

Turner replied, "Yes, your Lordship, but there is four shillings for the 'ackney cab bringing it 'ere".

Another little story that relates indirectly to Turner and Lord Egremont. The latter was calling on Turner one day, at his home in London. Receiving no answer at the front door, he walked down the area steps and knocked on the back door.

A shrill voice bellowed out "Is that the cat's meat man?" This was Mrs Danvers, Turner's housekeeper, and the mother of his two children.

Turner was another of the fraternity who was very fond of cats, and there were many in and out of his house. One of the windows had a broken pane left unrepaired, so that the cats could come and go at will. To prevent a draught, Turner placed a canvas over the hole. The canvas was 'Bligh Sands', which is now in the Tate Gallery.

Artists are often quite slovenly at looking after their own pictures. For instance, the 'Old Lady with the Rosary' by Cezanne, now in the National Gallery. This was for some time in Cezanne's painting room, in close proximity to the stove, and from time to time splashes of water went on the canvas. Some of these can still be seen on the lower part of this masterpiece of Post Impressionism. I call it a masterpiece, although I cannot understand why it took Cezanne three attempts to get the bowed shoulders of the old woman as he wanted them.

A pathetic creature, she was found wandering in a dazed way about Cezanne's house, and became a kind of domestic help. She had

an unfortunate habit of stealing various articles of his clothing, and then selling them back to him as paint rags.

Cezanne was one of that coterie of geniuses we call the Impressionists...perhaps the golden age of French painting. He sometimes went sketching with Pissaro, who has been called the Father of the other Impressionists, but this accolade really belongs to Monet. I also think of Pissaro's visits to this country, and the beautiful pictures he painted in the environment of the Crystal Palace. And then there is the painting he did of the road that leads to Dulwich.

Years after Cezanne's association with Pissaro, he was speaking to a friend who had also known the latter, and Cezanne said "Oh, I remember him...good and simple like God".

The struggle the Impressionists had before they were accepted is one more example of the tardy recognition given to some art forms. When Monet was a young man and a struggling painter, he lived with a girl and they were both on the brink of starvation. In desperation Monet wrote to his parents, asking them if they would allow him to return home.

They agreed willingly, but said that he must leave the girl behind. And so, Monet left the girl to the care of Boudin, that exquisite artist who, at this time, was also struggling.

Times change and paintings by Boudin, which at that particular time would have been bought for a few francs, are now worth thousands of pounds. And Monet, on returning to his parents' home painted a picture called 'The Terrace'. It consists of a sunlit garden overlooking the sea, with his father sitting in a chair bathed in sunshine.

Monet sold the picture for the equivalent of seventeen pounds. Not so long ago it was sold for one of those mind boggling sums which the Impressionist's paintings command today.

These are examples of the quirks of fate and fashion.

CHAPTER 9

Impressionism,
Post Impressionists,
the Edwardians,
vision and variety

Still on Monet, as a young man he painted two very large pictures, in an effort to establish himself. One was 'Girls in the Garden' and the other, I think, 'The Picnic in the Garden'. They were so big that a ditch was dug in the garden and the pictures suspended on pulleys, so that they could be lowered or raised at will. This was done in order for Monet to be able to paint on them.

Eventually they were left in the possession of the innkeeper where he had been staying...presumably in payment for his board and lodging. They were stored in the basement of the inn, and many years later retrieved, by which time they were in a poor condition, because of the dampness in the basement. It was, however, possible to salvage something of the paintings, and these large rescued portions are now preserved for the nation.

Towards the end of his life Monet's sight was impaired, but he was encouraged to go on painting by his friend, the French statesman Clemenceau. It is a fact, to be admired, that during the dark days of the First World War, possibly at the instigation of Clemenceau, a special studio was built. This was in order that Monet could continue painting...an example of French civilisation!

Monet became a noted and venerable figure in France. Pilgrims would come to see and talk to the great man, and look at the

water lilies in the beautiful garden he had created at Giverny where he lived.

The series of water lily pictures he painted...a forerunner of the modern Abstractionists...are now in the Orangery, an annexe at the side of the Louvre which retains the name it had before the Revolution.

As a young man Monet said he wanted to paint like a bird sings. His wish was fulfilled.

And, I suppose we can say, when considering his extensive opus, that he sang like a bird at dawn.

We admire the works of Pissaro and the other household names in the Movement like Renoir, but they all stem from the inspiration of Monet. Some were more scientific than others, and some show their reading of the scientist, Chevreau, whose writings on the analysis of colour had great influence on their painting. Bridging the centuries, the analogy of the writings of Vitruvius had much the same impact on the artists of Italy as Chevreau had on the French Impressionists.

Of course, the concept was a little slow in being accepted, yet Goethe, for instance, noticed the blue shadows on the sunlit flowers in Schiller's garden, and also Delacroix, sketching a market place in brilliant sunshine - a sketch he was making from a stationary cab - observed the blue shadows against the sunlit street.

Some call French Impressionism the Golden Age of French painting, but by Jove, what a hard struggle they had to be accepted. Battling against poverty, many fell by the wayside, but luckily for us from Monet to the other great surviving Impressionists, their work is part of the glory of French painting. Since then French painting seems to be lost in experimentation.

We mustn't forget, however, Manet's swan song, the incredibly beautiful picture 'Bar at the Folies Bergere'...one of the masterpieces in the Courtauld Collection. As a student I would stand in front of that picture and feel a life enhancement at its beauty.

Like all beauty, great art is an enhancement of life.

The next phase in art brought the Post Impressionists. I give one hundred percent for some of the art of Van Gogh. I remember standing in front of his greatest masterpiece, 'The Garden of Arles', where the poor demented soul was a patient at the hospital. The picture shows a great dark tree, deep blue in colour, overhanging a brilliant

sunlit path. It seems as though the tree painted in this dark blue has the paint showered on it in frenzied agitation, over the heavy impastoed path of brilliant Naples yellow. Any picture beside this masterpiece would seem weak. I recall a similar situation. There is a landscape by Turner of brilliant colour, hanging beside a beautiful picture by his imitator, Pyne. The latter was a lovely work, but beside the Turner it paled.

The Post Impressionists decided that the Impressionists had become painters of visions of loveliness, but had forgotten the actual structure of what they were portraying. For example, when Monet painted a picture of the façade of Rouen Cathedral, his one idea was to show the sunshine on the Gothic masterpiece. In fact, there was no more substance than if the façade were a pink sponge.

The Post Impressionists decided to bring back solidity to the subject. However, although Cezanne said he wanted to make an art as enduring as the art of the museums, and to repeat the art of Poussin, I still find some of his classical pictures of nudes rather suspect. I can't understand the admiration of so many art lovers, when they look at his 'Bathers'. On the other hand, I wholeheartedly admire Cezanne's landscapes, with their strong sense of structural form and washes of delicate colour, that achieve the goal of undoubted masterpieces.

However, all his faults and virtues can be seen in the painting of the old nun 'La Vieille au Chapelet' in the National Gallery, where despite his intellectual pursuit of his theories, we of more ordinary emotions see an old woman struggling to keep her faith.

Cezanne took pity on her and she became a part of his household, as a servant and general cleaner, the same woman I referred to earlier who sold back his shirts to him as paint rags.

It is true that Cezanne was significant in the evolution of art. It was Roger Fry who said "If we consider the significance of Giotto in the evolution of art, and his importance, then we must respect the importance of Cezanne in the Modern Movement".

The Post Impressionists were the successors of the Impressionists, and the forerunners of the Cubists. All later manifestations, Braque and the other Cubists, stem from the influence of Cezanne. Here and there are painters who attempted to reconcile the various styles at this time. I suppose Seurat is the most obvious

example, where he tried to combine the colour of the Impressionists with the rigid structure of the Post Impressionists.

After that, we come to the many experimental efforts of the so called research painters, who produced laboratory works.

Many modern art scholars think that much of their work should never have been exhibited. They are, indeed, research works, trying to find an acceptable idiom. Looking at so many of their pictures, it seems many are a tragic waste of human endeavour. They are accepted because of the pearls that now and then appear, for example the exquisite work of Modigliani.

Through all the long history of painting there is the main vision, that stems from Giotto up to today. But, here and there, as an alternative, are side paths, that occasionally produce works of great beauty. Here I would cite as examples William Blake and Samuel Palmer...work quite different from the usual accepted art of the period, but still both unusual and beautiful.

Unfortunately, these paths are usually cul-de-sacs, and the inspiration of their work withers in their followers. But the main stream, as I said, from Giotto onwards, goes on.

After Monet and his contemporaries it could be stated there was little else to be said for Impressionism. In my opinion, that also goes for most of the Post Impressionists and, subsequently, the Cubists. The Fauves provided an interesting interval with Matisse and his disciples, but they ran their course, and there is very little of their work in contemporary painting. Perhaps today we are awaiting a new voice, that can take its place beside the accepted masters of the past. If one goes to the Royal Academy Exhibition now, I do not think many of the works displayed will be illustrated in art books of fifty years hence.

We mustn't forget the contribution made to art by the many very fine women artists. The Italian School had some wonderful artists, and Artemisia Gentileschi, daughter of Orazio Gentileschi is an example. In France, Madame Vigee Le Brun produced beautiful work, as did the Swiss artist Angelica Kauffmann who, it has been said, had an affair with Sir Joshua Reynolds. And, in more recent years, the strong pictures by Lucy Kemp Welch, whose large horse paintings were features of the Royal Academy Exhibitions at the beginning of this century.

The Edwardian period was responsible for some fine painters...there was a kind of sunset glow in the pictures before the First World War. They included Shannon, Lavery and, of course, the brilliant Augustus John, and Orpen. There were so many first class painters of that period, all working with assured confidence, and their works were appreciated by the society of the day. Sargent, too, was a great force at that time, and some would say he was the giant among the others.

Today his work is under a cloud, and rather suspect because of his technical fluency. Now his work is looked upon as being too slick, but most of this criticism pales when we look at Sargent's 'The British Consul, Swettenham'. Here again it would now be said to show the arrogance of the British Empire, but it was no more than a symbol of the times. And when we look at the tentative way some portraits are painted today, it is a pity they fail to emulate to some degree this kind of work.

There is no doubt that Sargent was in great demand. He painted a series of portraits that included many of the leaders of society of his day. All this became something of an industry with him.

There was an insight into the character of many of his sitters that is a denial of the accusation by some critics that he was just a surface painter. A case in point is a woman he painted. After her doctor looked at the picture, the latter walked away very troubled. Sargent had noticed in her face something that the doctor had failed to see. She died in an asylum.

Sargent lived in great style in Tite Street. He was a big man, well over six feet tall and burly, fond of good living and fine cigars. He never married, and despite all the exterior bonhomie seems to have been rather secretive. He was a fine pianist. Towards the end of his life he painted a series of wall decorations for the United States, and used to make trips across the Atlantic to proceed with these. He thought highly of them himself, but today they are not considered to be that great.

One night he went out to post a letter which, I believe, was about these paintings. He came back home, and retired to bed with a French book. Having lived in France many years, he was a fluent French linguist and scholar. Next morning he was found dead in his bed with his spectacles propped up on his forehead, having been, no doubt, too tired to finish what he was reading.

At one time Sargent was all set to make his career in Paris, being as much at home there and elsewhere in Europe as he was in America or this country. He was a student of Derain, who was a very fine portrait painter and a good teacher. But, Sargent outmatched Derain, and became the foremost portrait painter of the day.

Among his French commissions was one to paint a portrait of Madame Gautreau, the somewhat notorious mistress of a well-known Frenchman. The portrait shows this stylish woman in a full length, very daring gown, which appears to be almost moulded to her beautiful figure. The picture was exhibited at the Paris Salon, and caused a sensation. People came into the Salon with the one idea of seeing this portrait. It did not please everybody and, indeed, some were shocked. Madame Gautreau's mother was incensed by the portrait, and this knowledge considerably discomfited Sargent who, hidden among the crowd, overheard visitors' comments. He became so embarrassed by the whole affair that he packed his bags, left Paris, and settled in London.

Sargent was lost to France forever, but this was England's gain.

Thinking again of Orpen, here is an anecdote relating to him and a contemporary of his, Alfred Munnings, another member of that same brilliant coterie in the Edwardian era.

I once attended a lecture at the Royal Society in Albemarle Street, where Munnings was to give a talk on the art of George Stubbs. Needless to say, Munnings venerated Stubbs' work and, I believe, he also venerated the book by Stubbs on the anatomy of the horse. Munnings, in his lecture, and among his many digressions, spoke about going to see an exhibition of one of Stubbs' masterpieces, 'Hambledon Rubbing Down'. It's a great picture with the horse almost life size, and Munnings related how he went to see it with Orpen.

Munnings, in his usual racy way, remarked on the brush work of the painting, and Orpen wondered what sort of brush Stubbs had used.

Munnings said "Let's have a look, Orpsy". He always referred to Orpen in this way as, indeed, did all his fellow artists.

So Orpen clambered on to the table, and examined the brush work carefully at close hand. Nobody looks at a picture as closely as that, except an artist who wishes to see the technique of how a picture is painted.

Sir William Orpen was, by this time, highly successful and lived in a fine house, with a palatial studio. Apparently he had an affair with a wealthy American woman. She was very tall, and Orpen was quite diminutive. The wags of London referred to the couple as Jack and the Beanstalk.

He produced many portraits of soldiers of the day during the First World War. Like Sargent, he was an official war artist. Possibly Sargent's greatest war painting was 'Gassed', which shows the poor blinded soldiers in one long procession, each with a hand on the shoulder of the man in front. Orpen's greatest war picture was 'The Unknown Soldier'. At the end of his days, Orpen was rather erratic, and the last paintings he produced show the slow decay of his former lively personality.

Augustus John, a contemporary and friend of Orpen, did some fine war pictures without the documentary value of those by Sargent and Orpen.

Other artists of that period produced work depicting the horror and tragedy...one can think immediately of Paul Nash's picture of the bombardments in Flanders where we see nature reduced to muddy swamps and trees reduced to bare trunks.

The parallel can be cited in the war poems of Rupert Brooke (who contracted enteric fever), Wilfred Owen, Julian Grenfell, Siegfried Sassoon and other brilliant young poets of the time. Their deaths on the battlefields were such a tragic waste of both genius and talent.

Coming back to the present time, everything in art is in a state of flux and experimentation. And it's difficult to know what these experiments will achieve. I'm inclined to think the art world clutches at straws, and frequently presumes that such and such a painter is a forerunner of a new style. One recalls the hostility that greeted the pre-Raphaelites on their first advent and, later, the Impressionists. Few modern critics will pass judgement on many of the pictures painted today. There must be some significance in some of the painters of today, but although certain critics give them fulsome praise at the moment, it remains to be seen if their work will endure.

Somewhere, I suppose, there is an artist whose work will act as a beacon to the next generation. Who would have thought that Constable would have influenced a century of landscape painters, when we think of his tardy recognition in his own day.

When Constable achieved the distinction of becoming a member of the Royal Academy, as was the custom he went round to the other Academicians to express his appreciation of their electing him to their august body.

On visiting Sir Thomas Lawrence, the then President of the Royal Academy, Sir Thomas said to him, "Mr Constable, you are very lucky to receive your R.A., there are many excellent historical painters who might have had more votes than you". At that time, the historical painters were very much in vogue, but today we appreciate the sincerity of John Constable's interpretation of the rich arable land of this country.

I suppose we inevitably look back with a nostalgic eye on the rich English countryside that Constable knew and depicted so well. Beauty is a delicate thing, and can be destroyed by so many means.

Much of the countryside that we admire in Constable's pictures was destroyed by the Industrial Revolution.

Consider, for instance, the dark satanic mills that Blake protested about, but which were considered necessary for the prosperity of this country. The Industrial Revolution brought wealth to the country, and untold suffering to many of the people who created that wealth. And, by so doing, ruined part of the English countryside. In place of this rich arable land of which I write, the country was crossed by the iron web of railways. Progress is bought at the expense of age old traditions.

I mentioned earlier the landscapes of Samuel Palmer. His father-in-law was John Linnell, but with Linnell's work there are two sides to the coin. One can think of Linnell's picture 'The Last Load' where we see the peasants taking home the last load at the end of a day's hard work. But, the backaching work is forgotten by the sight of the glorious sunset in the picture, transforming everything into a thing of wonder. No longer on show in the Tate Gallery, this painting is now sadly in the basement of the building.

John Linnell never received the accolade of the Royal Academy, but looking at his pictures we realise what a great artist he was. He lived to be a very old man, and was deeply religious.

Towards the end of his life he was offered the R.A., but is reputed to have said:

"You should have offered me this honour years ago, when I needed it. I can now sell my pictures without this distinction."

Rather sad is the passing of the great school of landscape painters. Today we are more interested in getting from A to B, irrespective of how much countryside we destroy in making roads. That's why, when we look at art exhibitions, very seldom do we see great landscape paintings.

It was Oscar Wilde who said "Nature follows art...for example, when fashion decrees a drainpipe figure for the female form, or another time when fashion decrees curvaceous curves".

In just the same way, when the English landscape was rich arable countryside, John Constable and his followers painted this beauty almost at its best. Then the camera came along, snapshots were taken of the brave new world, and we see railroads, telegraph poles and all the trimmings of a modern society.

One knows we cannot turn the clock back, and we all use motor cars. But, the invention of the internal combustion engine has caused inestimable damage to the environment, and the way we look at nature.

Perhaps the incredible amount of violence that we experience today and the violence that is perpetrated on our children is due in no small measure to the pollution of the atmosphere. This causes mankind to observe the world in a different way. Not so long ago, I was looking at a steel engraving of Victorian gentlemen at some celebration...I forget what. Near at hand, also, was a photograph of present day sportsmen attending a modern sporting event. It was striking to see the difference in the faces of the Victorian gentlemen and those of the contemporary sportsmen - the difference between a Victorian face and a twentieth century face. One shows the face of a mechanical society, and the other of people, many of whom took to the countryside for a living. A period idiom.

It is amazing how the countenances of generations change with their activities. One of the great realists of the past was Jan van Eyck. He studied the visual world with a penetrating gaze, and produced paintings like the marriage of Arnolfini and his wife. It is a miracle of exactitude, but we don't see people like that today. And the studied penetration of van Eyck's gaze has produced a marvellous document of people five hundred years ago. Their faces reflected the view point of civilisation at a certain period.

I suppose that was one of the last manifestations of the Gothic style. It was swept away with the Renaissance ideal, which we associate with the glory that was Greece and the grandeur that was Rome. That did not exist in the world of van Eyck and his followers. One could not expect to see a Venus or Apollo in van Eyck's world.

How strange is the evolution of taste in various phases of civilisation. Mankind goes through these different periods, searching for truth in a multiplicity of ways. With the collapse of the classic world, mankind started a long groping towards a search for truth...however, it was to be found. We can see the Gothic ideal in the building of the white mantle of Gothic cathedrals, buildings that sprung up across Europe in the Middle Ages. There was a fervour in the minds of so many people, and God and the Saints were tantamount to real people. Of course, the Classic world had the same idea, but illustrated it in a different way. To the scholars and philosophers of the ancient world, Venus and Apollo and the great family of gods and goddesses were as real as the Christian calendar of the Gothic Middle Ages. This everlasting search for truth, which is the glory and tragedy of mankind.

There was a school of thought which said that about 1000 A.D. the world would come to an end. And with the thousand year millennium, Christians started building cathedrals. All the great cathedrals that we now admire really stem from that period when mankind, searching for faith and a reassurance of its own salvation, built them. It was, indeed, a stupendous faith, for the men who started to build them knew they would never see their completion.

They are a manifestation of all that is best in mankind. Not only the fabric of the cathedrals, but the extensive carvings and the wonderful stained glass windows, which have never been surpassed .

The lead cames that surrounded the jewel like stained glass gave the enrichment to these great Gothic cathedrals.

On the other hand, with the Italian cathedrals there was little need for the stained glass windows that we find in the northern European buildings. In the north, the climate was dull, but inside the cathedrals, the windows shone like jewels. Witness the beauty of Salisbury Cathedral, or in a more extravagant setting, Chartres in Northern France. These windows were not necessary in Italy, as the sun gave all the light that was required. No doubt, to the cathedrals of Italy fostered on the writings of Vetruvius, they had little in common.

Like all great works of art their preservation is tenuous. One can think of France, and the destruction of the great monastery of Cluny, a hallowed place where the order of Benedictine monks lived. The monastery was destroyed in the French Revolution as a mark of protestation by the peasants for their hatred of officialdom and authority.

During the Revolution there was similar savage destruction of so much that represented authority, and which was a symbol of the oppressors of the community.

Danton stood and looked at the glories of Versailles...which was, of course, one of the reasons for the Revolution...and said "This must all go".

One can imagine him sweeping his hand to embrace all that was so similar in that utterance, and a fragment of the opulence of pre-Revolution France in the Wallace Collection in London gives some indication of what caused the contempt and hatred emphasised by Danton among others. It is a source of amazement that so much of that period has survived.

As an example of what did survive, in the Wallace Collection there is a fine example of French horology. It is a long case clock by one of the great horologists, which was whitewashed all over and then smuggled out of France at the height of the Revolution. When in safer hands, the clock was cleaned, repaired and all the whitewash removed. Today it can be seen, as it was, in all its beauty. The senseless ferocity executed by the mindless in times of great stress is one of the tragedies that can afflict works of art. Not only did it apply in France, but also in Russia during the Bolshevik régime. Sanity now having been restored to both France and Russia, what is left of their bygone heritage remain treasures of this time.

Art has no morals. Also in the Wallace Collection are superb pictures by Francois Boucher of 'The Rising of the Sun', and 'The Setting of the Sun'. At the time of Madame Pompadour, they were painted as designs for the tapestry workers of the day. I don't believe the tapestries from these two masterpieces were ever produced. Be that as it may, Madame Pompadour so loved these two striking pictures that she prevailed on her Royal protector, Louis 15th, to give them to her. Another example of the embarrassment of riches which is in the Wallace Collection.

The large room, which I presume was once a ballroom, is now filled with a staggering array of masterpieces. Franz Hals' 'The Laughing Cavalier', works by Velazquez and so many more that they have to be seen to be believed. This great collection, in what was formerly the town residence of Sir Richard Wallace, was bequeathed to the nation, and is the most munificent bequest ever given to England.

One of the aristocrats who survived the Revolution was Tallyrand. He became an important post-Revolution figure, as an ambassador from France to this country.

When sitting in one of our salons and one must remember that some of these places were very magnificent at that time - Tallyrand would say "But, you've no idea of the opulence in France before the Revolution".

The splendour of the Royal Pavilion at Brighton gives some idea of the exquisite display in this country not so many years after the French Revolution. It may not have been quite as extravagant as pre-Revolution France, but it wasn't a bad second. And so the gradual decline of this self aggrandisement continued.

The Duke of Wellington lived at Apsley House, and a grateful country gave him Strathford Spaye, a country residence. Lord Nelson was rewarded for his victory at Trafalgar with the great house called Merton. Lord Kitchener was handsomely rewarded for his military exploits. However, after the last war, Viscount Montgomery fared in a much simpler manner.

Today things are different. The relentless pursuit of greatness by mankind has worn a little thin in this age of the common man. One of the last giants was Sir Winston Churchill, an outstanding statesman. He towered above his contemporaries, much to the annoyance at times of rival politicians. And, sometimes, his great orations in the House of Commons were exasperating to his opponents. Attlee is reputed to have said that he was tired of Churchill's monologues. Possibly, in post war England, the monologues were not so necessary but during the dark days of the war his words gave strength to the nation.

The possibility of Hitler winning the war was too dreadful to contemplate. With the peace there was, in any case, a complete change in the lifestyle of many people. The magnificent effort by all in the United Kingdom to ensure victory took a heavy toll. Nevertheless, there was a feeling of euphoria throughout the land on the day of victory.

Subsequently, that feeling of euphoria, while it lasted for a considerable time after VE Day, eventually faded in the presence of post war difficulties. It is a source of wonderment to many people that, despite the fact we were one of the victors, the defeated powers are now among the most prosperous nations in the world. It is, indeed, a different world.

Things that we discuss today were unknown before the war - such as the micro chip, atomic energy and many other scientific wonders. They are now taken for granted. Post war, there were two great schools of thought in the art world - the fervour that greeted the styles of the Bauer House and, on the other hand, a turning back to an almost Victorian style of decoration. The brave new world was not very popular with many people as a method of living. And the antique period became, paradoxically, something of a cult during the early sixties and afterwards. The beauty of wood is much superior to the brilliance of chromium plated metal. Some of this avant garde furniture was very expensive when it was new. Now that the craze has weakened, the only place it can be found is in third rate snack bars.

There have always been side shoots from the main stream. They have a brief effect, and usually wither, leaving the main stream to go on. That main stream in the arts goes back to the great masters, such as Michaelangelo and Raphael in art, and Shakespeare in literature. The offshoots may embrace such interesting experiments as Art Nouveau and the Surrealists. The same applies in literature. Interesting though they may be, they represent a facet and no more. Lewis Carroll and William Blake in literature, or in art, Edward Calvert and Samuel Palmer represent major experiments of these romantic side paths. So often, however, these become a cul-de-sac, and their followers either fade away or join the main stream.

Traces of their influence can be found in the followers of the great tradition. In art, Cezanne and Picasso leave some influence on the main stream. The only art form that seems to be breaking away from tradition is architecture. Modern architecture with reinforced concrete and girder construction is completely divorced from the classic styles. In fact, to see a modern building tricked out with classical details is obviously an anachronism.

One of the most interesting manifestations of art appreciation can be seen in the layout of modern art exhibitions. Today, pictures are

displayed in a very stark manner, which allows one to enjoy each picture by itself. If we examine the art galleries of the past...I am thinking of those as portrayed by Pannini or David Teniers...we see that the pictures are hung cheek by jowl with each other. In fact, they are hung so closely together that it is almost impossible to enjoy one picture on its own. In the past there was this romantic conglomeration of works where no attention seems to have been made to differentiate between works of different schools.

There have been great collectors all through the ages, but sometimes the idea of collecting many years ago was rather farcical. There were such things seen in the collections of that time, as a piece of wood supposedly from Noah's Ark, or a treasured exhibit of a Unicorn Horn. For once, there is much to be said for today's more scientific approach.

CHAPTER 10

The petals of the cherry orchard

So much has been written throughout the ages on all manner of subjects and all aspects of life. Words are the great bridge between ideas, thought, and finally realisation. Without words, no one would know what anyone else was thinking, hence the importance of language. One of the saddest things today, particularly among the young, is that they seem to have little understanding of the wealth and beauty of the English language. Apart from the most sterile of communication necessary for the continuation of life, they use only one or two phrases or clichés to express practically every emotion. There are, no doubt, various reasons for this, but that does not improve the situation. While one does not wish to extol verbosity, it is unfortunate that little effort is made to communicate in a more expansive manner. How much is lost through this blindness to the use and beauty of words. When, at least, will some recognition be made of this great lack in modern education, and some effort made to rectify it?

It has been said that poetry is the greatest of the arts. Whether or not one subscribes to this viewpoint, it has long been realised that the contribution of poetry has immeasurably enriched both literature and life. Literature without the divine genius of the great poets cannot be imagined. From Shakespeare, to the most humble, they have supplied the strands of gold in the web of everyday existence. This has helped people burdened with the problems that beset us all. They have plucked at the strands, and heard the music of words, and this has brought relief to them in their trouble. Language can mirror all emotion. It should reflect an image that is accurate as well as positive, and expressed in the

best possible manner. This prerequisites the knowledge and use of words.

An intelligent understanding of the arts is, to my mind, necessary for a full participation and understanding of life. It is no use going to a stately home or whatever on high days and holidays, then coming back to drab everyday existence and almost immediately forgetting everything that one has seen and enjoyed. These great feats of endeavour, and their attendant beauty - from the houses, gardens, paintings and furniture, to say nothing of other works of art displayed - were made to be used and enjoyed, and remembered. They were the best people could do...that's why we try and preserve them. Utilitarianism is all very well, but it is very sterile. Think of the concrete monstrosities of the sixties, and the sad, barren, housing estates. Built without imagination or hope - and people were expected to live happily in them. No wonder that riots, depression and suicide emanated from these awful conceptions. The spirit of man was stifled there, and the hopelessness that pervades so much of modern society found a ready breeding ground in these places. When George Frederick Watts painted his famous picture 'Hope', he depicted his subject as a young woman sitting on top of the world, and holding in her hands a large lyre. All the strings were broken, except one. This last, unbroken, string is Hope. The cynical may say this is maudlin Victorian extravaganza. Not at all. Without hope there is no vision for mankind. Coupled with faith, it is a necessity for existence. To try and to keep on trying, no matter how bad things may seem at the moment. 'Hope' is an example of how painting and one man's vision threw out a lifeline, that was a golden strand. A touch of genius.

All great painting has a sense of vision. It is an effort conceived in that idiom. A good novel, which should be an accurate mirror of people and their everyday life, portrays and records...it does not always have a sense of vision. It can help, amuse, instruct and delight, and while one can say that to some extent painting does the same thing, the impact is different.

Like George from the timber yard, who used to sit in silent wonder and contemplation in the picture room, people looking at paintings are at the receiving end. The message is always there. That the interpretation of the message differs from one person to another

only underlines the universal appeal. People are different, and their reactions, therefore, can never be the same.

A casual look at any great painting is never enough. The underlying nuances will only become apparent after a long time...sometimes a lifetime. But the pleasure that emanates from the final understanding is worth all the effort. To know all is to understand all.

Certain people in the wide circle one gets to know through work and social contacts have often said, why Cherry Orchard Road? Why stay there, when the whole world beckons? It is a backwater, shorn of its earlier life and industry. Now, it has little to offer.

Backwaters, however, have their appeal as well as their uses. Here, familiarity dulls the need for conscious effort. Some more pretentious houses need living up to. Here, it doesn't matter. Like a well worn coat, that one slips into for ease and comfort, the old house and garden remain an enclave.

It is true that, here and there, the walls may be crumbling, but they are lined with books, so the distress doesn't show. And the inconsistency of the plaster work doesn't matter, when it is hidden by pictures. Here, a family lived and worked, and had its being. The rooms would echo with the sound of music, and children's laughter. At Christmas time, the tree in the corner, and crib, dimly lit and mysterious, embodied the worship of the Child in the stable at Bethlehem. All this one remembers, and feels it tug at the heartstrings. This was life as one knew it. Slow and without demand, like the touch of a gentle hand.

Being born, and always living in the same place, ensured an emotional as well as a practical continuity. And, in the old days, it was good from the point of view of shopping and transport. But, of course, with so-called progress, all that has changed. Nothing remains the same, except, perhaps, in memory. And maybe it's not good, always to be looking back. However, that is the prerogative of the old.

When one's life has been dominated by a great passion...the love of painting and pictures...it is good to know that what one has loved will always remain. Nothing, no matter how great or trivial, can take that away. From time to time, it may be augmented or diminished by circumstance, but the central flame continues. Many people think that those men and women who have it are fortunate, because it gives a

focal point to existence. No matter what hardship is endured in the attempt to achieve the goal, the effort will always have been worthwhile. That's good to know, because the sentiment excuses what is often the poverty of the result!

There are good pictures and there are bad pictures, and probably a greater number of the latter than the former. The only sadness is when the aspiring artist thinks an appalling painting that he has executed is the work of genius! This, unfortunately, is sometimes true...an illusion some people live by. Most artists, however, are dissatisfied with their work, and will always strive to do something better. That keeps the wheel turning, and it is the way it should be.

Except with some of the great artists, their work does not always improve with age. That is not the same thing as saying it improves with time. A mellowness may be manifest with the passing of the years, that was lacking at the beginning. At a certain period in his life, the artist is at the height of his prowess, and this has always been recognised. With some, of course, this comes with maturity, but not always. It differs from one person to another. There are some artists who will always want to live to paint, and usually they go from strength to strength. But with others, the early desire deteriorates into merely painting to live. It is not always easy to strike a happy balance, and here the vision may be lost.

Some people are full of early promise, and apparent great potential. Often this is never realised, and the May morning of that promise sinks into a barren Autumn, followed by a Winter of despair. The full flowering of the talent never comes. This is sad, but as I have said before, the solace still lies in the fact that the effort was made. Many are called, but few are chosen. A truth that will always apply.

No true artist is ever satisfied with his work, and I'm not only talking here about painting. The novelist, the playwright, the poet, will all throw away or burn their efforts from time to time, as will the artist with his canvas. Each will cry that they will never again put pen to paper, or lift a paint brush and stand at an easel.

But, of course, they do. The urge to create is too strong to be ignored. That is the blessing that has been bestowed on those born with a talent, no matter how slender. One likes to think this will always be the way in life. It has certainly been so through the ages.

The road, the shops, the people, and presumably, before that, the cherry orchard. Where are they now, all those who rang the bell and came through the shop door, with a picture under their arm, and a question on their lips?

Can it be restored? What is it worth? Would you like to buy it? The considered attention, the quiet talk, and often the itinerant laughter. So many people, so many pictures. They wind away in the mind's eye, like a long meandering stream, of which one never sees the end. Over the years they must have numbered thousands, maybe tens of thousands, but who is counting? One remembers so much, but one also forgets. That blessed oblivion, that the passing of time allows. Man could not bear it, if he were ever conscious of each nuance of existence.

How long ago, one wonders, was the cherry orchard planted? When the delicate petals drifted across the paths, blown this way and that by a freshening breeze, was the young Victoria on the throne? Or, perhaps, her uncle, the bachelor William? Who can tell? So much is lost, and yet the tenuous links remain. The pale shades of those who lived and worked here, maybe still haunt what was once their proud domain. The cascades of music, that echoed through the rooms of the old house, perhaps, can still be heard by the listening heart. The brilliant waterfall of sound emanating from the fingers of the initiated, in sharp contrast to the stumbling octaves wrung out by the hands of eager children. Each was recorded and stored, in the memory of the ancient walls. Where are those children who clattered down the stairs, their young hearts full of expectation? Grown to maturity, married and with their own children. The everlasting cycle that is the foundation of life.

And, so it goes on. To remember and to record, no matter how imperfectly. In the beginning there was so much to hope for, and so much to expect. If it didn't always work out to the full realisation of what one had expected, then who is to blame? The fault, dear Brutus, lies not in our stars, but in ourselves. As usual, the Bard got it right. He had a monopoly in eternal truths. And, he was an Englishman. A fact it does well to remember.

In these days, when so many people, through various misguided ideas, try to denigrate our island race and the achievements, both past and present, of its sons and daughters, one should think hard about the intransigence of such utterances. It may be trendy to give

voice to certain ideas, but it is neither truthful nor honest, let alone loyal. Why does the Left like to decry what the Right extols, and vice versa? It can be argued that both are necessary to achieve a balance. The result, an ordered democracy, in what might otherwise be a blatant bedlam. And here, at least, the individual is allowed to speak without fear or recrimination. It would seem there is no beginning and no end, just the struggling and sometimes fevered efforts of each individual. The trials, and the occasional achievement. So much crowding on the canvas, it is impossible to remember the detail, yet when the tale is told impossible to forget. A tale told by an idiot. Once more the Bard was right. One can go on so long, soliloquising and reminiscing. But, enough is enough.

The young dismiss the old, and the old tolerate the young. Each sometimes forgets that the condition of the one will, given time, apply to the other. The children racing to buy a pennyworth of sweets from Mrs Winter's shop, and the old man swinging his arms...they all contributed in their own way to the scenes depicted in memory. Perhaps the most enduring is the cherry orchard, that one never saw, except in imagination.

"It is so warm today that we can keep the windows open though the birches are not yet in flower...I remember perfectly that it was early in May and that everything in Moscow was flowering then", was the cry of Olga in Chekhov's exquisite play. All she ever wanted to do was to leave her provincial home and go to Moscow, as did her sister Irina. And, again in 'The Cherry Orchard', the sound of the axe being wielded underlies what is happening, because the cherry orchard has been sold. Perhaps each of us cries in our hearts about our own particular cherry orchard. And, each of us longs to go to our particular mythical Moscow. What does it really matter what it's called? To each one of us it is the city of our dreams.

Dreams, those evanescent brief escapes from life that are replaced on waking by a dull reality. Or is it? The answer to that probably lies in our own hands.

The thought of the heartbreaking beauty of the little walled garden, with its wealth of flowers, will always remain. At the end of each day on summer evenings, one could sit, and remember. But, nothing lasts. It had seemed this innocent pleasure would go on forever, but suddenly it ended. The spectre of ill health lurking in the

background, and subsequent immobility, made even the walk in the garden impossible.

Even so, looking back it was all worthwhile, although there are always some regrets. It would have been nice to have been able to carry on working, because work is a necessary adjunct to happiness. When a man has no work, he is usually unhappy. Work has a beautiful dignity, whether it be skilled or otherwise. One always wishes what one did could have been better, and one always hopes it fulfilled a need and occasionally gave pleasure.

To give and never to count the cost, even it if requires all your strength. One can only try, and trust it is enough. Thoughts, like the lost petals of the cherry orchard, drifting in time. So much to remember, before it is lost forever. So much, and still so much...